A Paradise in the City

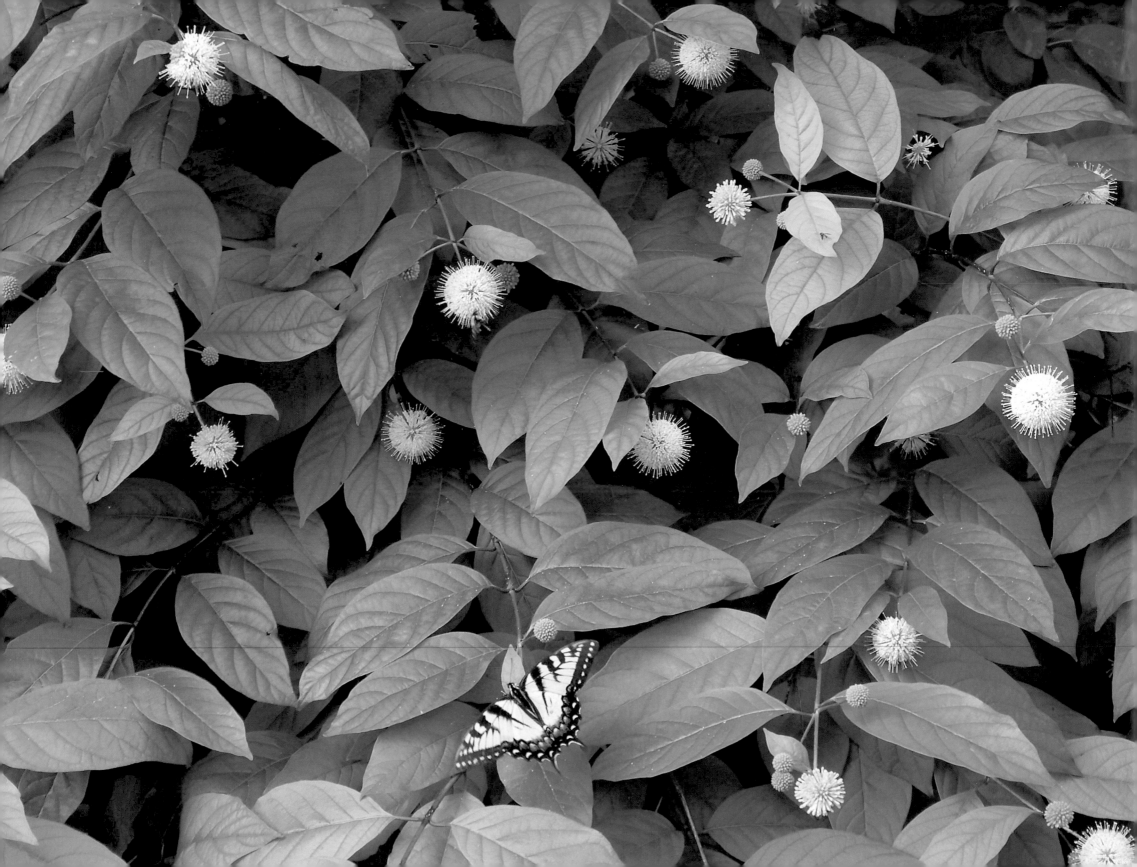

A Paradise in the City
CLEVELAND BOTANICAL GARDEN

Photographs by Ian Adams and Jennie Jones

Foreword by Brian E. Holley

Text by Diana Tittle

ORANGE FRAZER PRESS
Wilmington, Ohio

ISBN: 1-882203-46-1
Copyright 2005: Cleveland Botanical Garden

Ordering information: Additional copies of *A Paradise in the City: Cleveland Botanical Garden* may be ordered directly from:

Customer Service Department Cleveland Botanical Garden Store
Orange Frazer Press or 11030 East Boulevard
P.O. Box 214 Cleveland, OH 44106
37 ¹/₂ West Main Street 216-707-2800
Wilmington, OH 45177 www.cbgarden.org

Telephone 1-800-852-9332 for price and shipping information
Order online at: www.orangefrazer.com

Library of Congress Cataloging-in-Publication Data

Tittle, Diana, 1950-
A paradise in the city : Cleveland Botanical Garden / text by Diana Tittle ; foreword by Brian E. Holley ; photography by Ian Adams and Jennie Jones.
p. cm.
ISBN 1-882203-46-1
1. Cleveland Botanical Garden. 2. Cleveland Botanical Garden–Pictorial works. I. Adams, Ian, 1946- II. Jones, Jennie, 1932- III. Title.

QK73.U62C585 2005
580.73771'32–dc22

2005040482

BOOK AND JACKET DESIGN: Jeff Fulwiler
PRODUCTION DIRECTOR: Marcy Hawley

PRINTED IN CHINA

When we create gardens,

it is paradise that we ultimately

wish to achieve. Our Garden

has moments when it comes

remarkably close.

Brian E. Holley

Executive Director

Cleveland Botanical Garden, 2005

C O N T E N T S

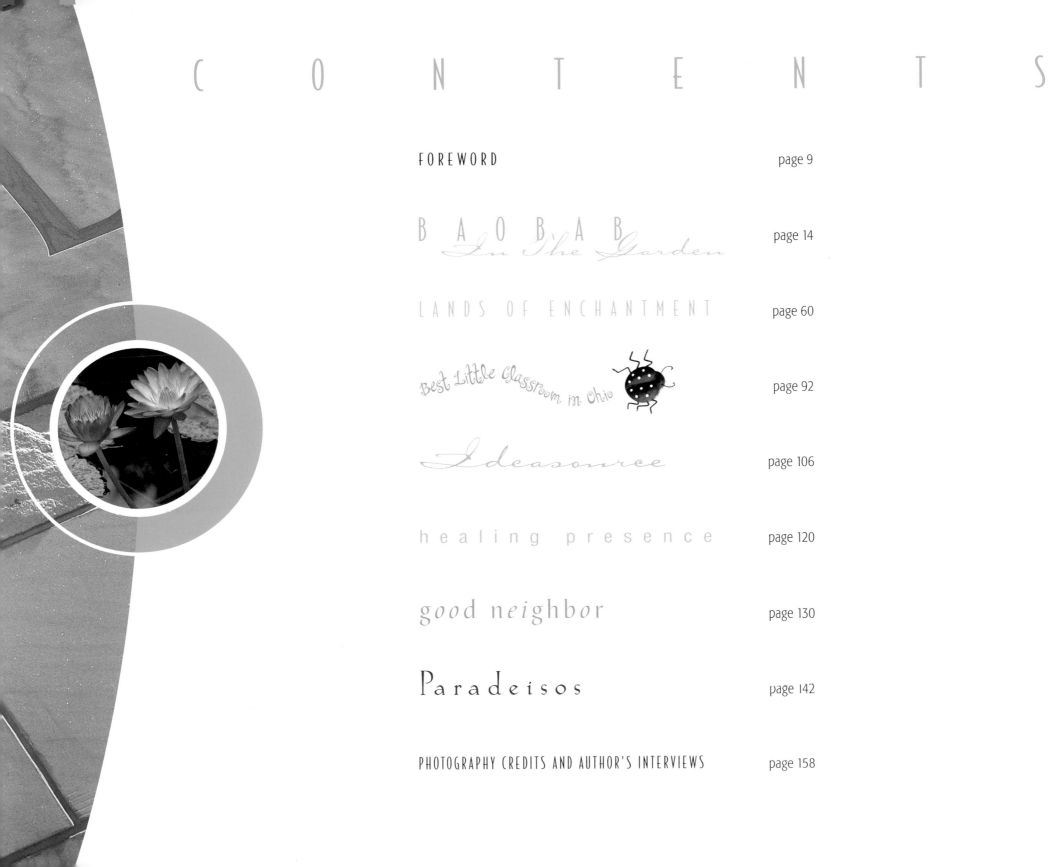

Foreword

Almost 20 years ago, I visited what would become Cleveland Botanical Garden for the first time. I was struck then, as I am today, by the jewel-like quality of its gardens. Here were beautifully designed spaces with diverse collections of plants, set in perfect scale to their urban surroundings.

Since arriving to work here in 1994, I have had the opportunity to walk the gardens almost daily, watching the changes as days lengthen and shorten and the years pass. Each season has brought its pleasures, as colors burst out of the landscape, children laugh and play, gardeners study, and waves of migratory birds flutter in for a brief respite. The years have brought growth and new jewels to our collection of gardens.

More recently, I have expanded my daily rambles to include the Eleanor Armstrong Smith Glasshouse, visiting daily with the weird and wonderful life of the Madagascar spiny desert and the glittering butterflies and verdant world of the Costa Rican cloud forest.

For many years, Ian Adams, Ohio's leading landscape photographer, and I have been talking about creating a book of images that would capture the beauty of the gardens and the joy and intellectual curiosity that they inspire. It was never the right moment until now. Cleveland Botanical Garden's 75th anniversary in 2005 provided the perfect occasion to compile a dazzling selection of Ian's photographs of the gardens throughout the seasons.

This book also captures the Garden's amazing transition of the last few years in the wonderful work of noted photographer Jennie Jones. Jennie's studies of the transforming construction of our new building and her elegant portraits of the Glasshouse plants are a great complement to Ian's work. Thom Sivo, a regular photographer for most of Cleveland's major magazines and publications, is also represented here, as is Bridget Commisso, a brilliant young photographer.

I have long admired the thoughtful prose of Diana Tittle and was delighted when she agreed to write the text for this book.

These contributors have created an enduring volume that reflects the pleasure that millions of us have found in the gardens and the continuing vitality of programs that touch our community.

Reading Diana Tittle's introductory essay has been both an enlightening and a humbling experience. All of us involved with Cleveland Botanical Garden are proud of the growth of our community programs, gardens and facilities during the last decade and the acclaim that we have received for their innovation and quality. For all that, as I read and reflect on the remarkable achievements and foresight of our founders, it becomes apparent that today's vitality is built upon 75 years of talented leadership.

The story of the Garden Center of Greater Cleveland's growth into today's Cleveland Botanical Garden is a powerful reminder of the potential of our actions to impact the future. This institution originated in the need to find a home for 250 gardening books when these volumes could no longer be stored at Cleveland Museum of Art. Today, we have 250,000 visitors a year, 10,000 members and programs that touch people throughout Greater Cleveland and as far away as Madagascar.

The Garden's leaders were fearless in their vision. When, in 1935, they needed funding for the Garden Center, they introduced The White Elephant Sale. The sale was a key source of income for the Garden for 65 years and ultimately made *The Guinness Book of World Records* as the largest rummage sale in the world. In the 1960s, the leaders decided that the little boathouse in University Circle that served as headquarters was inadequate to meet the needs of the community, and set about building a new facility 10 times larger. They were not only successful in raising the funds, but they also built one of the city's most beautiful buildings from that period.

The history of great board leadership continues today. I have found great pleasure in my friendships with the six presidents and the dozens of trustees with whom I have worked. Indeed, these relationships have been one of the most satisfying aspects of working at Cleveland Botanical Garden.

Special thanks should be extended to our crack publication team: Peter Vertes, Karen Allport, Mark Druckenbrod, Ann McCulloh, Cynthia Druckenbrod, Robert Rensel and Helen Tramte.

Finally, thank you to Diana, Ian, Jennie, and Marcy Hawley and Jeff Fulwiler of Orange Frazer Press for your creativity and acumen! Without your passion for the Garden and your knowledge of publishing, this book would not be so beautiful or evocative. I thank them, a tremendous staff and group of volunteers and a host of wonderful supporters for making this history of the Garden a reality.

—Brian E. Holley

 January 2005

A Paradise in the City

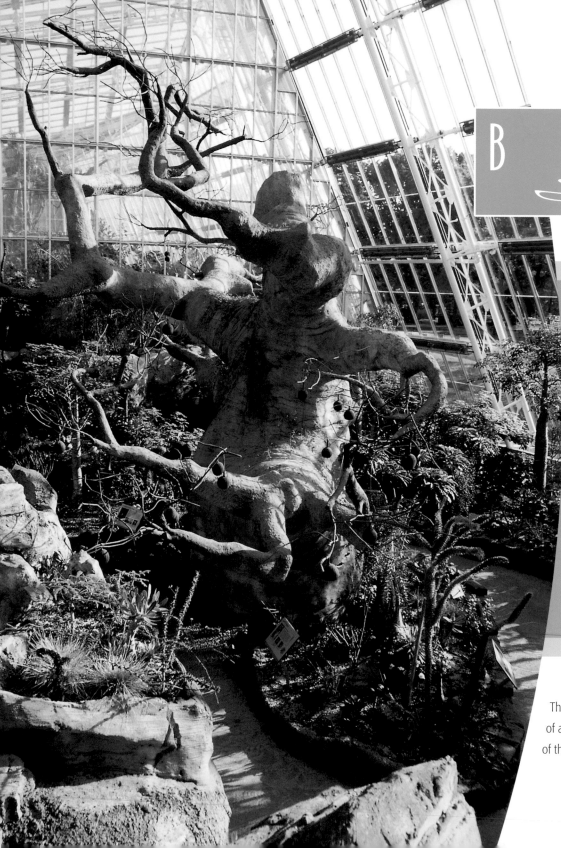

BAOBAB
In The Garden

THE BLOSSOMING

of CLEVELAND BOTANICAL GARDEN

by DIANA TITTLE

The Madagascar biome in the Eleanor Armstrong Smith Glasshouse: A 30-foot-tall replica
of a magnificent baobab species, *Adansonia za*, is the centerpiece of this living panorama
of the island's desert-dwelling animals and succulent and thorny plants.

Legend has it that the gods, tired of listening to the baobab's pleas to be made as graceful as the palm or as beautiful as the flame tree, angrily pulled the baobab from the ground and replanted it upside-down to stifle it. But the baobab continued to grow and became the "tree of life."

The baobab is one of the world's oddest-looking plants. It appears to be standing on its head. A spray of serpentine boughs that resemble gnarled roots sits atop the baobab's trunk, which can rise straight into the air like an inverted baseball bat, twist into a pear shape or assume the form of a pigeon, depending on its species. There is a reason for the baobab's bizarre proportions. It stores vast quantities of water in its pulpy trunk, thus ensuring its survival in semi-arid tropical regions.

During the dry season, the upside-down tree is leafless. During the wet months, it sprouts a lacy emerald canopy, dotted with flowers that open only at night.

The African baobab was the first of the genus to be seen and described by a Westerner, the 18th-century French naturalist Michel Adanson. Typically a solitary plant rising from the savannah, *Adansonia digitata* is an ecosystem unto itself. It feeds and shelters multitudes: insects, snakes, rodents, birds and mammals. Another type of baobab can be found in Australia, and the remaining six species are endemic to Madagascar, an island off the east coast of Africa.

Like their African counterparts, the indigenous peoples of Madagascar depend heavily on the "tree of life." They eat its fruit, extract cooking oil from its seeds and make rope and thatch from its bark.

If a baobab escapes destruction for cattle fodder or deforestation, it can live 1,000 years or more. At death, it implodes. Madagascan peoples naturally revere a being possessed of such powers. They leave offerings at its base to ensure their good fortune.

To experience the baobab's magic, you can travel 9,000 miles to Madagascar. Or you can visit Cleveland, Ohio. There, in the Eleanor Armstrong Smith Glasshouse of Cleveland Botanical Garden, grow not one, not two, but five Madagascan baobabs. Representing two species—*Adansonia rubrostipa*, which has reddish-brown bark, and *Adansonia za*, whose bullet-shaped trunk can grow to be 100 feet tall—this is one of the largest collection of Madagascan baobabs in the United States. The baobabs are presented in full ecological context, in a living panorama of the succulent and thorny plants, desert-dwelling animals and simple tools of the Mikea people of southwestern Madagascar.

The strength of 12 people was required to lift the largest of Cleveland Botanical Garden's specimens, a 1,500-pounder found near a clay pit in Madagascar, onto an oxcart to begin the journey to Ohio. The baobab's export was permitted because of the precarious location in which it was growing. The rescued tree survived a plane ride, two-year quarantine and replanting (a feat that required a crane).

The baobab's journey is nearly as remarkable as that which its new home on the shores of Lake Erie has undertaken. Today a rising star in Cleveland's cultural firmament, Cleveland Botanical Garden functioned for most of its history as a service organization for gardening and horticulture enthusiasts. From improbable beginnings in an ad hoc project to preserve a collection of 250 gardening books, it has blossomed into a one-of-a-kind visitor attraction and a leader in the field of botanical and environmental education.

The most visible sign of Cleveland Botanical Garden's transformation is the Eleanor Armstrong Smith Glasshouse, an 18,000-square-foot conservatory melded to the façade of the organization's longtime headquarters in Cleveland's University Circle. Its dynamic, stepped roofline suggests that this is no ordinary

conservatory. Designed by Graham Gund Architects of Cambridge, Massachusetts and completed in July 2003, the Glasshouse contains two biomes, each interpreting the diversity of flora and fauna in a contrasting ecosystem. The Spiny Desert of Madagascar, in which the baobab thrives, is a gift of the Paul and Maxine Frohring Foundation, and the Cloud Forest of Costa Rica, home of the equally fascinating "Great Cloud Forest Tree" —the strangler fig—is a gift of Celia and Albert Weatherhead.

The Costa Rica biome features a true-to-life replica of a strangler fig, the "Great Cloud Forest Tree." This tree avoids the struggle for light in the forest's dense understory by germinating high in the canopy of a host tree and sending roots down to the ground.

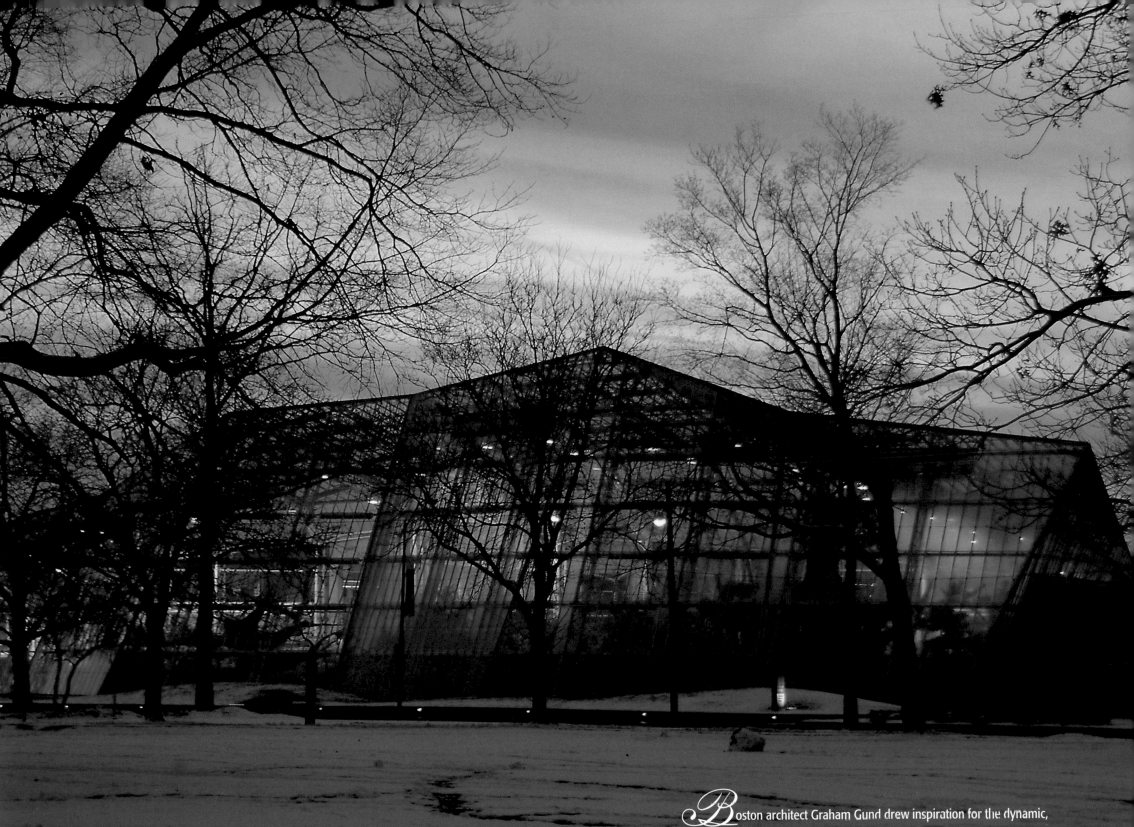

Boston architect Graham Gund drew inspiration for the dynamic, stepped roofline of the Glasshouse from the facets of an amethyst crystal.

Each of these unique ecosystems has been authentically recreated, using 350 species of plants and 50 species of animals, in order to illuminate the amazing ways in which plants adapt to their environment, demonstrate the interrelationships of all living organisms, and spread appreciation for vulnerable habitats. True-to-life replicas of a 30-foot-tall baobab (a gift of the Louise H. and David S. Ingalls Foundation) and a 40-foot-tall "Great Cloud Forest Tree" (a gift of Lois U. Horvitz) are the dramatic centerpieces of the two biomes. Viewed from the street at night when the Glasshouse is lighted, the inky silhouettes of the two iconic trees morph into giants—emblems of the Garden's heightened powers to enchant and educate.

At once an urban oasis, source of horticultural information and inspiration, living science lab, environmental advocate, healing presence and catalyst for urban renewal, Cleveland Botanical Garden now serves people of all ages and interests. Attorney Donald W. Morrison guided the organization through its critical first year of reinvention, as board president in 1993-94. He counts the Garden's new capacity to meet a broad range of needs as the most important change that has been achieved. "Before we served our members," Morrison says. "Now we serve the community."

In years gone by, for example, children frequented the building primarily during winter and spring recess, when the organization mounted popular holiday floral exhibits. Now the hallways resound with the chatter of excited youngsters. In fact, children under 12 and their mothers are the Garden's most significant new audience, says Karen L. Allport, director of marketing and communications. Between May and October they come in droves to enjoy the Hershey Children's Garden, named in memory of Jo Hershey Selden and her husband, Alvin A. Hershey. In this half-fantasy, half-pastoral landscape, kids can locate their birth dates on a four-season sundial, dabble their toes in a marshy bog, pump water to sprinkle on the flower beds surrounding a sod-roofed prairie cottage, pick vegetables on a farm scaled to their pint-sized proportions, or take home a seed they themselves have planted in a cup. In short, the children's garden is an interactive classroom that embeds its lessons about plants, gardening and nature in opportunities for play.

At once an interactive classroom, source of horticultural information and inspiration, healing presence and urban oasis, Cleveland Botanical Garden serves people of all ages and interests.

Almost as soon as it opened its fanciful wrought-iron gates in 1999, Hershey Children's Garden gained national attention for the creativity of its landscape design and for its educational inventiveness. Visitation reached the 100,000 mark within the first 24 months of operation. Indeed, the professional and popular success of the children's garden—the first in Ohio and one of the first in America—helped to build support for the even-more ambitious Glasshouse.

The Glasshouse was the cornerstone of a successful $50 million capital and endowment campaign that made possible other much-needed improvements: new gardens, classrooms, library and office space and such visitor amenities as an atrium, café, expanded gift shop and underground parking garage. "The Hershey Garden showed that we could do something out of the ordinary—and do it very well," explains Anne F. Barnes, 2003-04 board president and co-chair of The Campaign for Cleveland's Garden.

VITALITY
of Purpose

When a baobab is burnt or stripped, it forms new bark and keeps on growing.

Cleveland Botanical Garden hums with purposeful activity seven days a week. To appreciate its vitality, you need only to consult a single page of its annual calendar. Take a recent May. At the beginning of the month, hundreds of March of Dimes supporters gather to celebrate their successful completion of a walkathon fund-raiser in the Garden's elliptical atrium, a popular new civic gathering space.

A few days earlier, a spectacular "mobile" of 750 individually strung bird-of-paradise blooms wafts in the ellipse. The inspiration of Cleveland florist Donald K. Vanderbrook, it is one of dozens of avant-garde compositions created by four master flower arrangers during Extreme Arranging, a four-day series of lectures, demonstrations and workshops mounted for those who appreciate flowers as art. Extreme Arranging is a satisfying foretaste of the biannual Cleveland Botanical Garden Flower Show, the largest outdoor event of its kind in the country, planned for the following spring.

Mother's Day weekend brings out dozens of intergenerational family gatherings for Saturday or Sunday brunch, another of the year's many special events. Before and after partaking of an elegant buffet, family members enjoy leisurely strolls through the botanical garden's 10-acre grounds, which are awash in the horticultural staff's pick of the "hottest" trends in spring bulbs and early summer annuals. In the Gan Ryuu Tei Japanese Garden, mothers and daughters pose for pictures in front of the garden's signature "dry" waterfall, executed

entirely in stones. A middle-aged man pushes an elderly woman in a wheelchair through a maze in Hershey Children's Garden. "Help!" he cries out playfully to his companion. "We're lost!"

As May progresses, the phone in the Eleanor Squire Library begins to ring more frequently. Each year some 4,000 calls come into the Garden's information hotline, staffed by librarian Helen Tramte, a trained horticulturist. A typical question: "What can I do about wasps?"

"Draw them!" might be the answer of the three- and four-year-olds who come out one morning in mid May to participate in a Bug Hunt. With the support of The 1525 Foundation Community Outreach Permanent Endowment Fund, the Garden has developed a spectrum of urban education programs, such as a summer gardening program for six- to 12-year-olds, and Greens Corps, a paid summer internship that offers urban teenagers training in horticulture, life skills and business. The Bug Hunt introduces the life-sustaining powers of plants to Cleveland's youngest citizens. Today's contingent is enrolled in an early childhood development program at a nearby church.

The tikes are armed with plastic containers and led out to the Woodland Garden, which spans a creek-fed ravine on the northeast side of the botanical garden's campus. "Is this the *jungle*?" asks one of the children.

Invited to dig in the forest litter, the kids unearth worms, spiders and potato bugs, which they carefully tote back inside to sketch. "This is their first experience with live bugs," their chaperone notes. "We tried digging in the churchyard, but we only found a couple of ants." After standing up and reporting on what each has learned about insect life, the little kids pack up their creepy-crawly friends and return them to woods, singing a chorus of goodbyes.

On another May morning, a yellow school bus deposits 35 or so middle-school students at the front door. Their teacher has been well prepared through the research she has gathered in the Constance Towson Ford Resource Center, where educators obtain new and useful classroom tools. The students have come to see firsthand the workings of ecological competition, a principle they have already studied in class. They are sent into the Glasshouse to record the ways plants compete for water and light when both are scarce. A high school volunteer, fulfilling the requirement of a senior-year project, accompanies a breakout group into the Costa Rica biome, where she helps members of the education department explain the attributes of one of the most complete collections of cloud forest flora extant.

The biome is a riot of green plants, all engaged in a mad scramble to reach sunlight and mist at the top of the forest canopy. "Can anybody identify a climbing vine?" the student interpreter asks. Standing next to a spiral ginger in the biome's lush understory, she invites a preteen girl to feel the plant's leaves and describe the sensation. "Ooooh," the girl cries, upon encountering a surprising velvetiness. "It feels like a blanket or something."

"That's because the leaves are covered in little hairs that help retain water," the interpreter

says. Benefiting from a strong sensory association, the middle-school student will likely have an easier time recalling this particular adaptation.

The authenticity of the Glasshouse habitats impresses the members of the horticultural society of the Indianapolis Museum of Art, who have come for a mid-week tour led by a personable, well-trained docent. (A corps of about 250 regular volunteers handles assignments ranging from mulching to ticket taking. Their service is indispensable to the Garden's smooth functioning.) Upon emerging from the recreated cloud forest, one of the visitors from the Hoosier State turns to another and proclaims: "That's the closest I'll ever get to Costa Rica!"

Toward the end of the month 400 senior citizens enjoy a half-day outing at the Garden organized by the department of aging in their home county. Perhaps because of the happy childhood memories it evokes, the Western Reserve Herb Society Herb Garden proves especially popular with the seniors. Even those needing the assistance of walkers and wheelchairs make a point of stopping by the famed garden, maintained to perfection by its owners and creators, the Western Reserve Unit of the Herb Society of America.

When the seniors arrive, a squad of society members led by garden chairperson Lynne Griffin is hard at work, pulling up the bulbs of spent tulips, tilling the soil to ready it for new plantings and weeding, weeding, weeding. When asked what motivates their diligence, an herb society member explains: "We have a reputation to maintain."

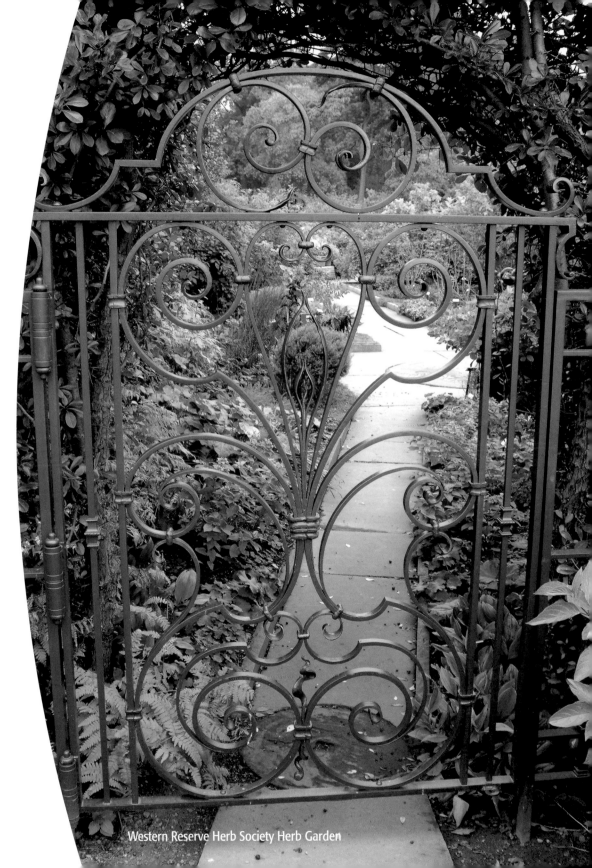

Western Reserve Herb Society Herb Garden

Society members delight in sharing their love and knowledge of herbs with visitors. "Remember horehound cough drops?" one of them asks the seniors who are observing her toil in the medicinal section of the garden. The volunteer gently breaks off a leaf of *Marrubium vulgare*, a member of the mint family, and holds it out in her palm. "Smell this!"

A woman in a wheelchair inquires of another volunteer who is picking grass one blade at a time from a carpet of green: "Is that chamomile?" "I have some of that," the elderly woman adds. "But I'm too old to get out in my garden, anymore."

As Memorial Day nears, the Garden presents a daylong symposium for health-care professionals on horticultural therapy, a field in which the organization pioneered in the 1970s and is still a national leader. Patricia J. Owen, the Garden's registered horticultural therapist, is a featured speaker at a morning of lectures on designing gardens to promote wellness. Owen has lent her expertise in this arena to the creation of the Garden's newest feature, the Elizabeth and Nona Evans Restorative Garden, a former reading garden that has been redesigned and expanded with gifts from the Evans family to accommodate both special-needs visitors and outdoor therapy. The Restorative Garden's dedication is the centerpiece of the symposium.

A post-dedication tour reveals that the garden remains a serene and lovely spot for reflection. New York landscape architect David Kamp, the principal designer, has resisted the use of expanses of concrete to guarantee accessibility and safety. His responses to the needs of the physically and mentally challenged are subtle. A lawn with turf strong enough to support a wheelchair, variations in levels of seating, Braille as well as English inscriptions, and the multi-sensory stimulation of falling and trickling water and especially fragrant or interestingly textured plantings—these refinements make the garden's beauty accessible to everyone.

A horticultural therapy class in the Restorative Garden

DREAMS
of Greatness

Many African cultures believe that one is safe from all harm when one takes shelter under a baobab.

To help Cleveland Botanical Garden fulfill its mission to interpret the wonders of plants, director Brian E. Holley found himself in Madagascar in the summer of 1999, trudging through several miles of blazing desert behind two herdsmen he had just encountered in the bush. The two men had offered to lead Holley and the other members of the self-described "Bab Squad" to an outstanding example of the great baobab of southwestern Madagascar. The specimen was located, the herdsmen had indicated through an interpreter, "over the next hill."

One hill having turned into many hills, Holley had almost abandoned hope of seeing a mature *Adansonia za*, when the party finally spied the majestic tree, whose trademark girth nearly exceeded its 40-foot height. "The feeling when you see one of these in the wild is remarkable, like coming upon a whale or a huge rhino," Holley remembers. Earlier on the expedition, he had seen a baobab cut down as fodder for thirsty cattle. This desperate act

The real-life "model" for the Garden's iconic *Adansonia za*

inspired in him the "sort of passion that I imagine I would feel seeing an elephant lying dead, killed by poachers for its tusks."

It was Holley's passion for plants that had brought the Garden team to this unique island, whose California-sized land mass hosts 8,000 species of flowering plants. Because Madagascar separated from Africa 175 million years ago, the preponderance of the island's plants are endemic, meaning that they are not found anywhere else in the world. The Garden hoped to acquire a compendium of the rare species found in Madagascar's spiny desert, including baobabs and examples of aloe, alluaudia, didieria, euphorbia, kalanchoe and pachypodium. The structural adaptations of these xerophytes (e.g., miniscule leaf surfaces to prevent water loss, thick, fleshy parts for water storage, and hairs, spines or thorns to reflect heat) gave them a zany appearance that reminded Holley of the illustrations in a Dr. Seuss book.

However, something greater than the desire to amaze and delight the folks back home inspired the Madagascan expedition. The Garden's board, staff and major benefactors shared a vision of the leadership role the institution could play in the fields of botanical and environmental education. Using horticulture (a subject to which both children and adults can easily relate) as a platform, Cleveland Botanical Garden dreamed of engaging children's interest in science and of raising public awareness of the world's fragile

ecosystems. To achieve these lofty objectives would require the organization (Holley realized) to do more than "just plunk down" its Madagascan trophies among other examples of semi-arid and arid species in a standard botanical-garden "dry" room. It would take a great deal of forethought and artistry.

Holley, his director of educational resources and two consultants—an exhibit designer and a cost engineer—hoped to gain an intimate appreciation of the topography, climate, flora and fauna of the island's spiny desert, one of the world's most endangered environments. With the firsthand knowledge and contacts afforded by the field trip, the Garden would be able to create a living, breathing replica of the Madagascan spiny desert—in Cleveland. This act of wizardry would take place in a spectacular new conservatory, or Glasshouse, that would also shelter a "wet" biome: the Costa Rican cloud forest, another special and extremely threatened environment. The contrast between the profuse, flowering beauty of the cloud forest and the spiny desert's parched, prickly landscape promised to be aesthetically striking and educationally fertile.

To heighten the pleasure of a casual visit and deepen the experience for learners of all ages, the Garden planned to take the extraordinary step of adding a zoological dimension to the Glasshouse exhibits. Animals indigenous to each featured habitat would be on display in each biome, and some would be allowed to fly or roam freely. Entomologist Cynthia Mazer (now Druckenbrod), who had formerly supervised the butterfly house at Callaway Gardens in Atlanta, Georgia, was recruited to become Glasshouse manager. She helped the botanical garden identify and obtain the fauna that could (as she put it) "live together happily under glass" with the planned flora.

In "Costa Rica," plans called for 20 species of neon-colored butterflies to flit in and out of the dense foliage (one reason why insect-eating birds could not be featured). A telescope would be trained on a colony of industrious leaf-cutter ants (which Mazer would be dispatched to Trinidad to collect), so that visitors could watch them march back and forth across a vine highway seeking forage. In the dry heat of "Madagascar," on the other hand, all the animal activity would take place in slow motion.

Dryas iulia, rightfully known as the "flambeau"

A nocturnal, quill-coated mammal called a tenrec could be expected to snooze away the day in the hollow of a log, while a pair of Oustalet's chameleons would be allowed to perambulate at will.

For the Glasshouse visitor watching a radiated tortoise tiptoe across the sand or coming face to face with a hairy tarantula hiding in a crevice of the strangler fig, the sensation would be one of total immersion in the sights, scents and sounds of a faraway world.

The proper presentation and preservation of Glasshouse plants and animals demanded sophisticated climate-control technology and an elaborate infrastructure, including 550 tons of soil, a running stream and 12-foot waterfall, and desert formations such as cliffs and a plateau. Also adding to the Glasshouse's cost: soaring height to accommodate a second-story platform in the Costa Rican biome that would provide views of the bromeliads, orchids and vines growing on top of one another on the uppermost branches of the strangler fig, and down into the canopy of avocado, palm and cecropia trees. If the Garden succeeded in mobilizing support for this significant cultural investment, Cleveland (home of a world-class orchestra and art museum and the Rock and Roll Hall of Fame and Museum) would boast yet another singular tourist attraction: the most authentic replicas of environmentally sensitive habitats on display in a botanical garden anywhere in the country.

And schoolchildren throughout the region would gain access to a living science lab. Indeed, the Glasshouse was conceived first and foremost as educational tool. Instead of passively touring the biomes, students would be engaged in hands-on investigations of their living ecosystems. Sandra Rode, who became director of educational resources in 1999, was already planning to collaborate with area teachers to determine the themes for age-appropriate classroom units that would lead up to a field trip to the Glasshouse. The units would be designed to impart basic horticultural knowledge, highlight important scientific principles and sharpen math and analytical skills. The Garden hoped to show educators throughout Northeast Ohio how to use horticulture as a curriculum to improve science education in the public schools.

In sum, the Glasshouse initiative was breathtakingly ambitious—especially for an organization whose operating budget barely topped a $1 million when Brian Holley was named director.

Holley came to Cleveland armed with nearly two decades of experience in a variety of horticultural and administrative positions with the Royal Botanical Garden in his native Canada. He assumed leadership at a critical moment. One month before his arrival in February 1994, the board voted to change the name of the institution from Garden Center of Greater Cleveland to Cleveland Botanical Garden. As the Cleveland *Plain Dealer* reported at the time, the trustees were "tired" of the center's being mistaken by the general public for a retailer of perennials and potting soil. In cultural circles the garden center had a different image. Because of longstanding affiliations with the area's garden clubs, it was perceived to be an exclusive social organization.

The board stood apart in recognizing that the 64-year-old Garden Center had untapped potential to become a cultural, educational and scientific leader. In addition to a well-maintained physical plant, a prime location near the Cleveland Museum of Art and Severance Hall (home of The Cleveland Orchestra) and a $13 million endowment, the organization had a strong tradition of civic engagement, social advocacy and educational outreach on which to build.

F O U N D E R S
and Nurturers

The Madagascan people call the baobab "Reniala," a title of respect that means "mother of the forest."

The first organization of its kind to be established in a major American city, the Garden Center of Greater Cleveland was the invention of a group of formidable women noted for seizing any opportunity, large or small, to provide uplift to their booming industrial city. The wives of Cleveland's business and professional leaders, these early 20th-century activists were themselves entrepreneurs who invested their time, talent and treasure in a progression of civic undertakings. Many of the city's present-day social agencies and cultural institutions and amenities can trace their origins back to the ladies' love of a good "project."

To cite a pertinent example of one of their most important projects, the wives of the city's captains of industry famously took it upon themselves to eliminate a notorious public eyesore. Under the auspices of the Garden Club of Cleveland, they commissioned landscape architect Frederick Law Olmsted, Jr., to transform the un-landscaped stretch of municipal

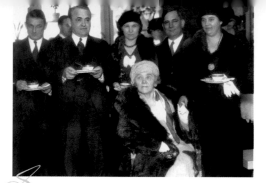

Spurred on by its leaders, including Mrs. William G. Mather (center) and Mrs. Walter C. White (right), the Garden Club of Cleveland established a civic garden center as a public repository for a collection of gardening books donated to the club by Mrs. Andrew Squire (seated). City manager Daniel Morgan (second front left) and Cleveland mayor John D. Marshall (second from right) attended the Garden Center's dedication ceremony on December 4, 1930.

parklands leading up to the Cleveland Museum of Art into a resplendent sculpture park. The unsettled fate of an abandoned city-owned boathouse on Wade Lagoon in the Fine Arts Garden was still nagging the garden's commissioners, when they learned of another problem. The Art Museum had asked to reclaim the space in which the Garden Club had temporarily stored a collection of gardening volumes and horticultural reference books donated by Mrs. Andrew Squire, the wife of a prominent Cleveland attorney.

At a Garden Club meeting in January 1930, Mrs. Thomas P. Howell, Mrs. Charles A. Otis, Mrs. William G. Mather, Mrs. John Sherwin, Mrs. Walter C. White and Mrs. Windsor T. White conceived of a neat remedy for the collection's homelessness. They would establish a civic garden center in the boathouse as the permanent repository of Eleanor Squire's gardening books. No matter that there were no organizational models in other major cities to emulate. The Center's founders envisioned precisely how they could "promote such

From its headquarters in a small brick boathouse on Wade Lagoon in University Circle, the Garden Center pursued an ambitious agenda: "to promote such knowledge and love of plants that will result in a more beautiful community." It was the first organization of its kind to be established in a major American city.

Miss Carroll C. Griminger, the Garden Center's second director, demonstrated how to grow plants from seeds to a children's education class in 1933. (To the right) The Garden Center's founders displayed a prescient concern for the environment, issuing pronouncements against highway billboards and hosting a 1933 traveling exhibit, "California Trees," organized by the "Save the Redwoods" League.

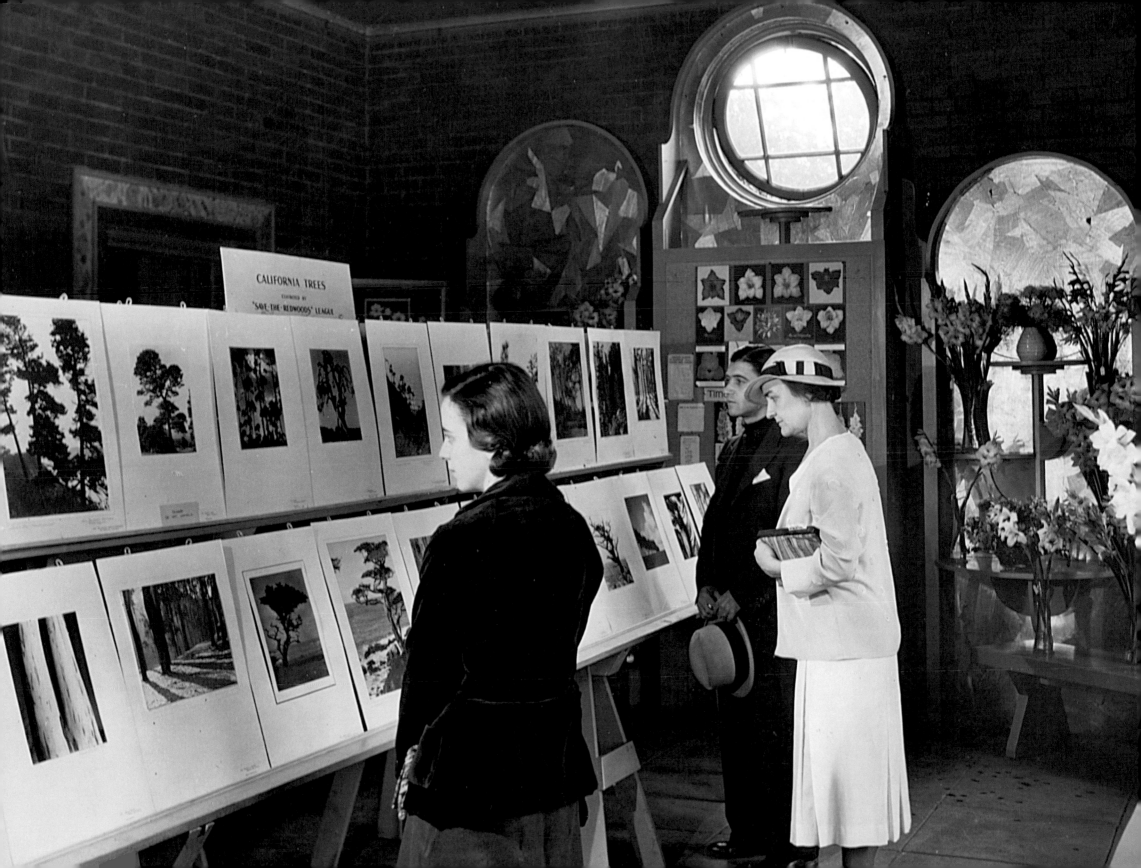

May 1934 "Tulip Show" testified to the talents of the Garden Center's affiliated garden clubs. (To the right) Holiday exhibits in the 1930s traditionally featured the handiwork of Boy and Girl Scout troops, such as this display of prize-winning birdhouses built by the boys.

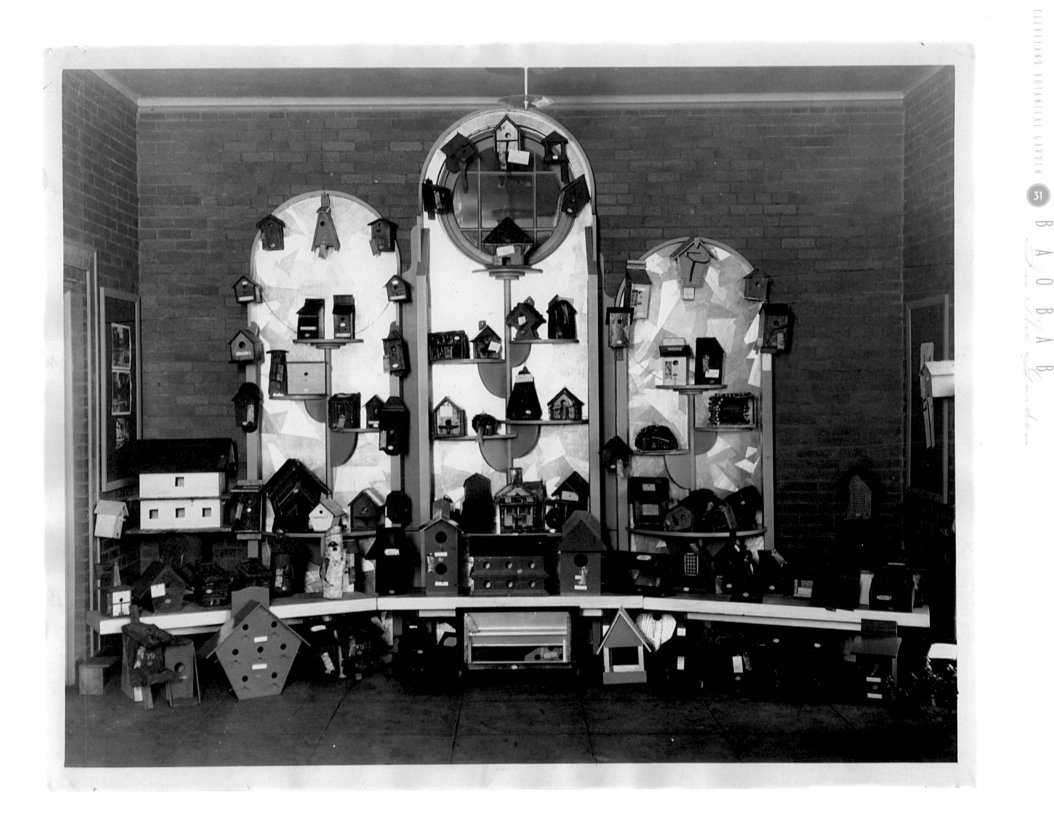

With the support of the federal Works Progress Administration and the City of Cleveland, the boathouse was expanded and remodeled in 1938. The Eleanor Squire Library gained larger quarters for its ever-increasing collection of how-to and reference books.

knowledge and love of gardening as will result in a more beautiful community." They would make public the Squire collection, offer gardening instruction to schoolchildren and adults, and mount free horticultural and botanical art exhibits for the edification of Cleveland's citizenry.

The Garden Center opened in December 1930. (After three years of sponsorship by the Garden Club of Cleveland, it became an independent organization with a new name: the Garden Center of Greater Cleveland.) For more than 35 years the Garden Center remained headquartered in the brick boathouse. Its only garden sat on the roof.

The Center's influence, however, was felt throughout the city.

As the Depression deepened, the Garden Center became a collection point for foodstuffs for the destitute, and some of its board members led citywide planning to convert vacant lots into relief gardens. During World War II, Cleveland's victory garden movement was headquartered at and administrated by the Center.

The beautification of Cleveland endured as a priority of the Garden Center's board members. They railed against the spread of billboards and led the effort to raise $50,000 to landscape Crile military (later Veterans Administration) hospital, hoping to speed the recovery of wounded combatants. In 1947 the Garden Center began to honor publicly local industries that beautified their corporate grounds. Commercial, institutional and educational categories

were later added to the Center's biannual awards for landscape design excellence. In the early 1960s the Garden Center organized field-day projects that undertook the re-landscaping of actual urban and suburban properties in order to educate the public about which trees, shrubs and flowers were best suited to these respective environments.

In 1963 Marie Odenkirk Clark became the Center's president. Mrs. Clark was 16th in a line of activist women (and two men) who "ruled the roost"—as former director C. W. Eliot Paine appreciatively terms the hands-on management styles of the Center's board leaders. Starting with her attorney husband, who was the president of the Leonard C. Hanna, Jr., Fund, Mrs. Clark began mobilizing support to build a more spacious facility. The Hanna Fund, the city's largest private foundation, made a lead gift of $500,000 toward the initiative, and Mr. Clark negotiated a lease with the City of Cleveland that gave the Center access to a three-acre parcel of Wade Park behind the art museum that had been previously occupied by the Cleveland Zoo.

A second major gift from the Elizabeth Ring Mather and William Gwinn Mather Foundation was followed by generous contributions from the families of the Center's other founders and area garden club affiliates. The outpouring of support made possible the construction of a $1.85 million building designed by New York architect William Platt, the son of the architect of Gwinn, the Mather estate. "When you have generous people on the board, things just *happen*," says Paine, explaining the impetus behind the Garden Center's postwar growth. "Things are accomplished quietly and with excellent taste."

Nestled into the hillside of a wooded ravine (still bearing evidence of the zoo's bear pit), Platt's understated, sandstone-clad building opened in January 1966. To take advantage of the dramatic expansion in exhibition space, program chairperson Iris Jennings Vail conceived of organizing a fair to display the produce grown each year by Cleveland public schoolchildren. The idea was the natural outgrowth of a student-gardener recognition program initiated by the Garden Center in 1936. Every year thereafter the Center presented awards to Cleveland public school students for outstanding effort in their school or home gardens. It was Mrs. Vail's belief that every student who entered the fair should receive a certificate; the three children whose vegetable, flower arrangement and specialty creation were judged best in show would receive custom-designed trophies called "Agricolas." This shot at fame propelled the competition's steady growth. "Some years we might have 20,000 tomatoes on little plates," Mrs. Vail says, an exaggeration that accurately describes the amazing profusion of entries. Iris Vail went on to chair the fair for 13 straight summers, from its inauguration in August 1966 until the school district disbanded its nationally regarded gardening program in 1978.

The Garden Center's 1966 building had opened with minimal landscaping. In 1968, the board asked the Western Reserve Herb Society to relocate its herb garden from nearby Wade Oval to a site just beyond the 24-foot-tall glass wall of Marie Odenkirk Clark Auditorium. Society members raised the funds needed to create an international showpiece. Designed by the pioneering Elsetta Gilchrist Barnes, one of the country's first female landscape architects, the Tudor-influenced herb garden was completed in 1969. A landscaped terrace offered a view of a massive central knot surrounded by seven specialty gardens of herbs grouped according to their uses (fragrance, culinary, dye and so on). Each specialty garden was framed by boxwood and hawthorn hedges, divided by low stone walls and paved with old millstones, bricks and sandstone. The Western Reserve Herb Society Herb Garden won universal admiration for its picturesque charm and educational merit, and its widespread fame helped to put the Garden Center on the map.

With the senior staff nearing retirement age as the Center turned 40, board president Elizabeth Whitney Evans addressed the need for more energetic leadership. In 1970 she recruited Alexander A. Apanius as garden consultant and horticulturist, and spirited Eliot Paine away from Cleveland's Holden Arboretum, where he was assistant horticulturist and education director, to become the Center's director. Paine, in turn, added librarian Richard T. Isaacson to the team. Each of the three men would leave his mark on the organization. "They had a beautiful building that was largely being used by area garden clubs for teas," Paine recalls. "We created a real program."

The new director devised a comprehensive curriculum of horticulture courses to be taught primarily by Alex Apanius—"practical, down-to-earth advice, like how to grow a lawn or raise a vegetable garden," as Paine describes the subject matter. He encouraged Isaacson's desire to systematically build the Squire Library's holdings and gave the librarian time to complete exhaustive research for what became *The Flowering Plant Index of Illustration and Information*, an invaluable reference book that the Garden Center published in 1979. It was the first of its kind.

Paine also gave the go-ahead to volunteers Nancy Stevenson and Mary Elizabeth "Libby" Reavis to develop a horticultural therapy program, one of the first in the country. The pair

"hauled big tubs of soil all over town," Mrs. Stevenson explains, with the twin objectives of using gardening activities to promote the well being of individuals confined to hospitals, nursing homes, golden age centers and children's agencies and to inspire those facilities to initiate horticultural therapy programs. In 1981 the Center hired Mrs. Reavis and Mrs. Stevenson to share a full-time horticultural therapy position, cementing the organization's commitment to the provision of healing services and leadership in this arena.

On the facilities side, Paine identified benefactors willing to partner with the Center on the creation of three outdoor gardens. The family of Mary Ann Sears Swetland commissioned a formal rose garden in her memory that was dedicated in 1971. Separated from the Western Reserve Herb Society Herb Garden by a panel of emerald grass, it featured hybrid tea roses displayed around an octagonal pool and fountain. Cleveland landscape architect Charles L. Knight conceived the garden's design, as part of the re-landscaping of scruffy Wade Oval, a beautification project initiated by the Garden Center and underwritten by the Sears and Swetland families.

The Nona Whitney Evans Reading Garden, donated by Betty and Raymond Evans in memory of their daughter, was dedicated in 1973. It was designed by Clevelander William A. Behnke to serve as an extension of the Squire Library. Doors in the wood-paneled library opened onto a greensward, framed by shrubs and perennials and studded with benches and an inviting gazebo shaded by a majestic chestnut tree.

Ikebana International, Chapter 20 raised the funds to set a Japanese garden into a hillside of the ravine in 1975. Designed by New York landscape architect David A. Slawson, Gan Ryuu Tei (Rock Stream Garden) combined elements of the classic tea garden with those of the dry-landscape garden developed by Zen Buddhist monks: a wisteria-draped trellis offering views of a teahouse reached by a crooked, stepping-stone path and a stone "cascade" in a surround of manicured evergreens, azaleas and ornamental grasses. It was a tour de force.

Each of the three new gardens was intimate in scale, so as to inspire (rather than intimidate) the backyard gardener. Open to the public 24 hours a day, they became popular urban sanctuaries, especially with those living or working in or near University Circle. Their beauty was safeguarded year after year by Alex Apanius, who had closely supervised the design, construction and planting of each garden. The son of a Lithuanian horticulturist who fled Germany to become superintendent of the William G. Mather estate, Apanius was a dedicated plantsman, gifted landscape architect and committed horticultural educator. In 1984, the Center's board invited him to succeed Eliot Paine as director, and he served in that capacity for the next decade.

Apanius's tenure was distinguished by the creation of a fifth outdoor garden, in the ravine, a former dumping ground that had been restored to its natural state through the efforts of John Michelko, the retired Cleveland commissioner of shade trees. In the mid 1980s, Apanius green-lighted a project proposed by Larry Giblock and other members of the Native Plant

Society of Northeast Ohio, who volunteered to help the Garden Center construct a wildflower trail through the ravine and publish an accompanying trail guide. Apanius subsequently hired Giblock to serve on the horticultural staff and encouraged him to develop a full-fledged Woodland Garden.

By the occasion of its 60th anniversary the Garden Center of Cleveland boasted seven acres of gardens, a 15,000-volume reference library (including a collection of rare books donated by Cleveland investment banker Warren H. Corning) and a substantive program of lectures, workshops, flower shows and art exhibits. For gardeners and horticulturists across Northeast Ohio it was an indispensable source of information and inspiration. Clara DeMallie Sherwin, the wife of the grandson of Center founder Frances McIntosh Sherwin, was among this loyal audience.

"The Center was a peaceful, lovely place, and I adored it," says Sherwin, a longtime trustee who became board president in 1995. "But my passion was to open it up to all. Gardening does a world of good for all souls. You can't walk down a beautiful garden path and not be a changed person."

Sherwin was not alone in her desire to see the institution's "public dimension" significantly enhanced. By the mid 1990s, a majority of the board had come to share her conviction that the Center must find a way to become more integral to Greater Cleveland. The intellectual heirs (and, in many cases, descendents) of the Center's founders, this group of trustees decided in 1994 that the time had come to transform the center into a botanical garden. The likelihood of this evolution had been predicted as far back as 1946 by then board president Eleanor Armstrong Smith, a protégé of Center founder Lucia Otis. Initial architectural drawings for the 1966 building included a round, freestanding conservatory, but it had not been built. Given how long the dream of metamorphosis had been deferred, it seems nothing short of remarkable that the transformation of the Garden Center of Greater Cleveland into Cleveland Botanical Garden was largely accomplished within the span of a single decade.

To celebrate Cleveland's sesquicentennial in 1946,

Mrs. William G. Mather mobilized a corps of volunteers

to create a garden on the roof of the boathouse.

The Garden Center's first formal outdoor exhibit space,

it was divided into seven small theme sections

to maximize its instructional value.

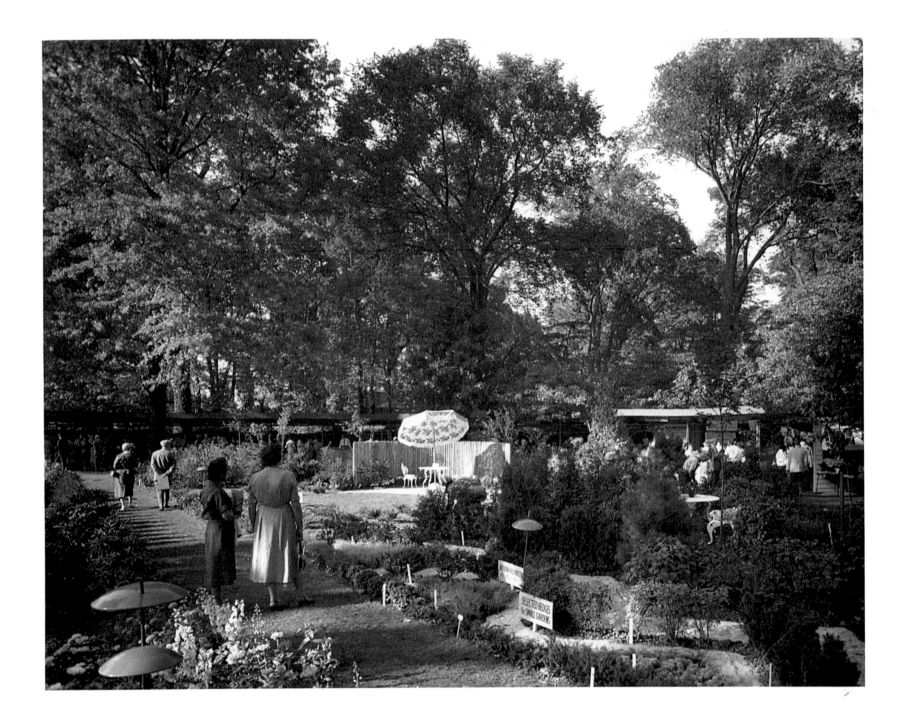

winn, Mrs. Mather's lakefront estate, played host to the Garden Center's first major outdoor flower show in 1956. More than 6,000 people attended the three-day event, which featured scores of exhibitors and a dozen "idea gardens."

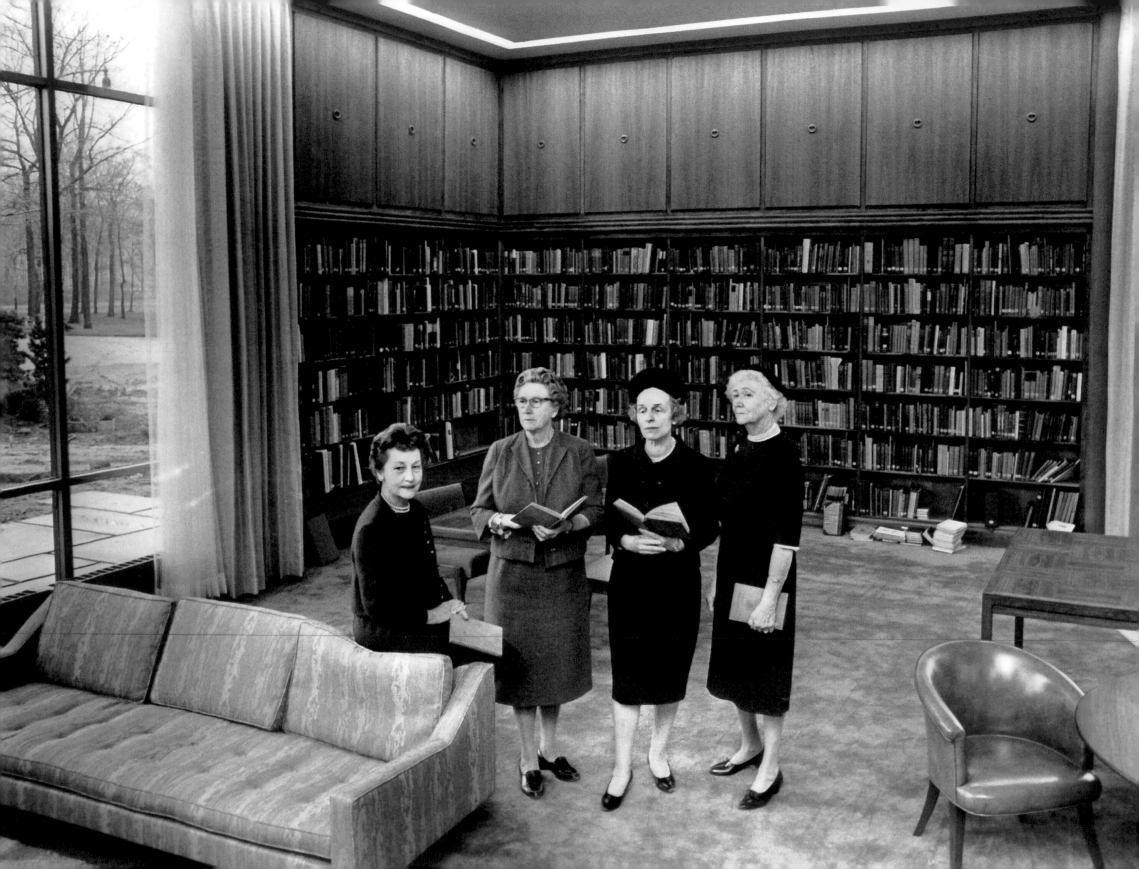

proud moment: Four past presidents—(from left) Mrs. Kelvin Smith, Mrs. Richard Nash, Mrs. Harold T. Clark and Mrs. Robert Jamison—gathered in the Eleanor Squire Library of the Garden's Center's spacious new headquarters shortly before the building's dedication in January 1966. During her tenure in 1946, Eleanor Armstrong (Mrs. Kelvin) Smith predicted that the Center would one day become a full-fledged botanical garden.

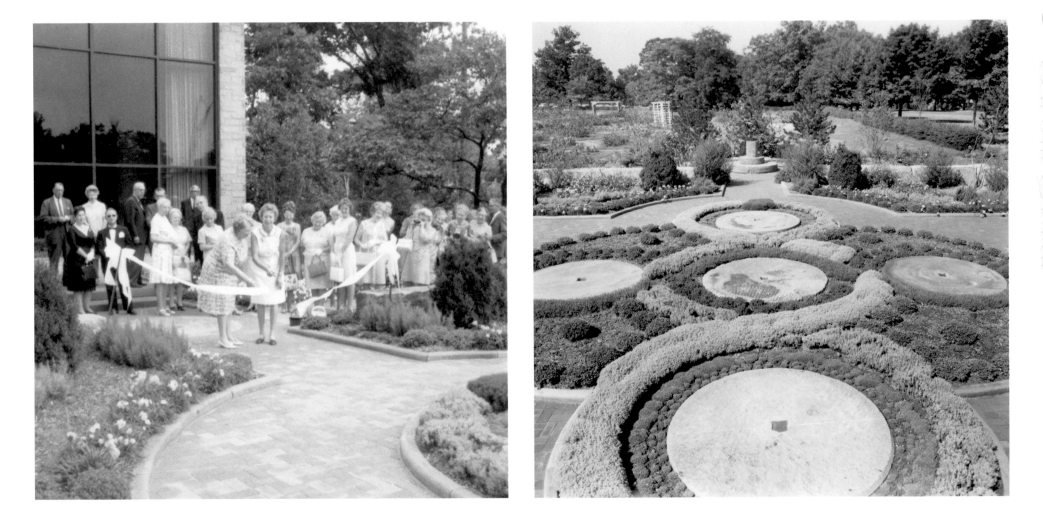

Almost as soon as it was dedicated in 1969, the Western Reserve Herb Society Herb Garden won universal admiration for its picturesque charm and educational merit.

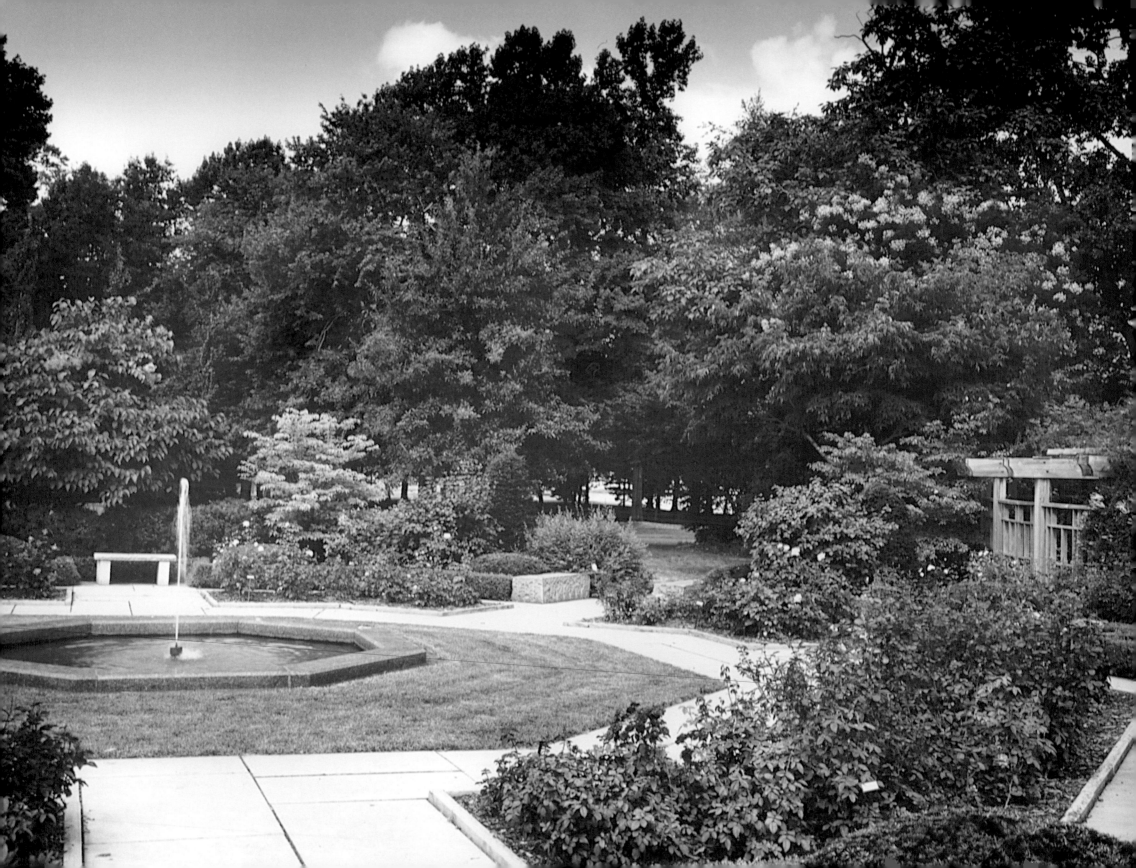

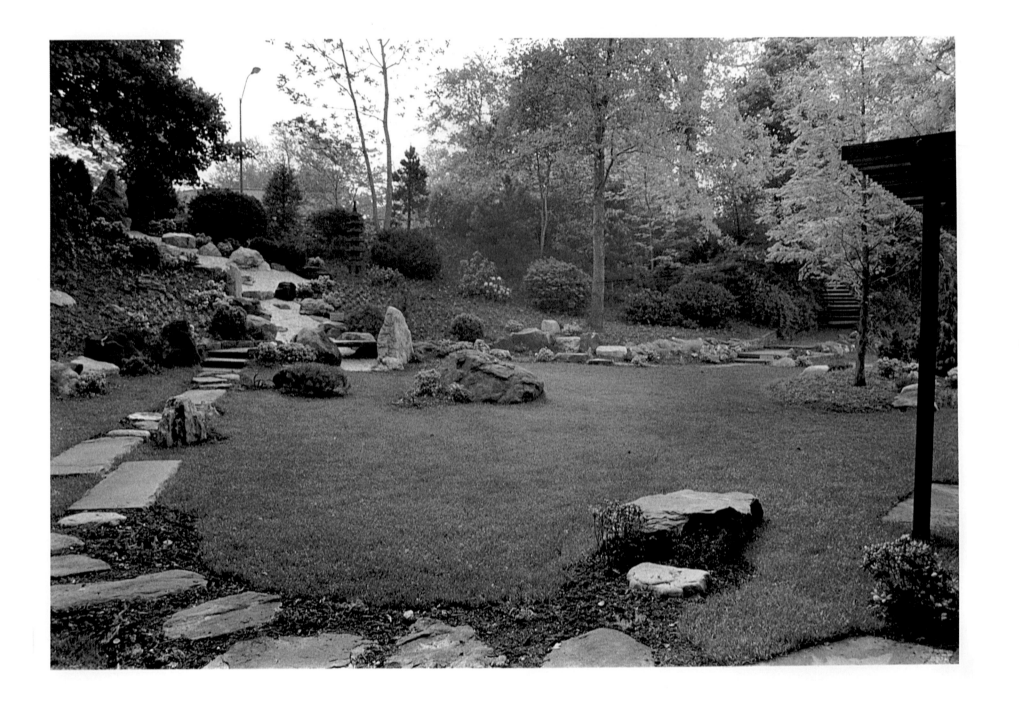

everal other much-loved gardens were created in the 1970s, with the help of generous benefactors. (To the left) In 1971 the family of Mary Ann Sears Swetland commissioned a formal rose garden in her memory. (Above) Ikebana International, Chapter 20 raised the funds to set a Japanese garden into a hillside on the Center's grounds in 1975.

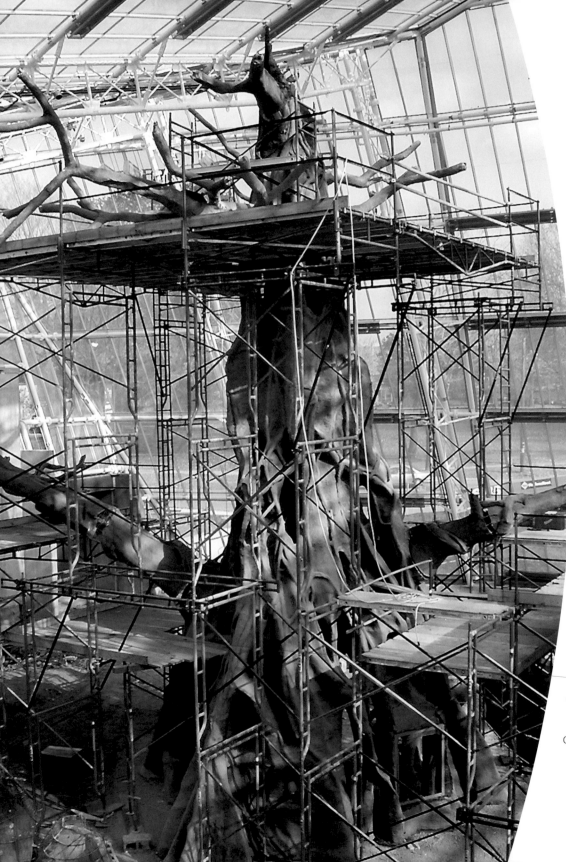

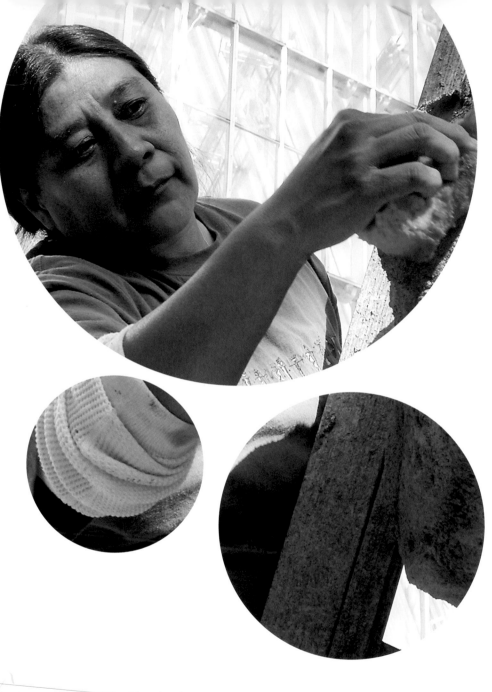

The "Great Cloud Forest Tree" is painted realistically and readied to accept a dense covering of orchids, vines and bromeliads.

SEEDING
Success

Certain African tribes wash baby boys in water used to soak baobab bark to ensure that the babies grow up mighty and strong.

Recognizing that additional financial resources and a detailed blueprint would be required if Cleveland Botanical Garden were to live up to the stature of its new name, the board hired a veteran development director named Lynne R. Feighan and began work on a strategic plan even before the arrival of Brian Holley. In fact, these signs of the seriousness of the board's intentions helped persuade the 44-year-old Holley to come to Cleveland.

Within a year of Holley's appointment, the board and staff completed a 10-year master plan. "Vision 2004" proclaimed the Garden's intention of being the pre-eminent regional source of horticultural and gardening information. The plan called for the expansion and meticulous documentation of plant collections and the creation of new opportunities for Greater Clevelanders to experience the beauty and fascination of plants. It committed the Garden to helping re-invigorate urban education in Cleveland and the quality of life in the inner city. Environmental advocacy was now a priority. The Garden intended to encourage stewardship of the earth's natural resources by demonstrating the interdependence of plants, people and habitats, and it planned to engage in research and partnerships aimed at advancing international conservation efforts.

"All these ideas came rushing out," Holley recalls, "like a dam bursting." A conservatory was chief among them.

The new director appreciated the fact that a conservatory would give the organization the year-round attraction it lacked. In fact, at the first meeting Holley held with his director of horticulture, Mark J. Druckenbrod, they had sketched on a napkin a form representing a conservatory and divided it in fourths. Each quadrant represented a contrasting biome. Druckenbrod, a tropical plant expert who had succeeded Alex Apanius as head of the horticultural staff in 1984, suggested that Madagascar, an ecosystem that he knew intimately from numerous visits, be among the envisioned four biomes. The inclusion of Costa Rica, a country that both men knew well, was "a no-brainer," Druckenbrod says. The conservatory design was later simplified to these two biomes and an accompanying exhibit interpreting the flora and fauna of Northeast Ohio that awaited discovery on the Garden's grounds.

It was clear that the fledgling botanical garden could not yet command the resources needed to build a conservatory. "Brian understood that we had to develop a credible educational program in order to build awareness and support," explains Ruth Swetland Eppig, a longtime trustee who served as board president and chair of The Campaign for Cleveland's Garden from 1997 to 2000.

Blueprints and construction work plans for the Glasshouse, a unique national attraction and living laboratory that was more than 10 years in the making

Already on the drawing board were plans for a simple learning garden. Holley's encouragement of board and staff to think more imaginatively gave birth to the Hershey Children's Garden. Maureen Heffernan, the newly hired director of public programs, contributed a variety of creative touches to the children's garden and spearheaded the development of other urban education initiatives. Gardening programs for youth and teenagers moved from brainstorms to reality. A headquarters for these summer programs was secured when Banks-Baldwin Law Publishing Company generously donated a yellow-frame century home and relocated the quaint structure to unused acreage on Cleveland's East Side made available by the Dunham Tavern Museum.

Dubbed The Learning Garden, the complex had more than enough room for multiple vegetable gardens, to be planted, tended and harvested by elementary-age children and preteens who lived in the central city. It was not long before the teenage members of the Greens Corps gardening program were turning each summer's bounty into thousands of jars of "Ripe from Downtown" salsa and successfully marketing the home-style product. There was also space at The Learning Garden for the Northern Ohio Perennial Plant Society to plant flower beds, in the hope of inspiring people living in the surrounding neighborhoods to do the same. With the same objective in mind, Western Reserve Herb Society member Jane Toth turned a rudimentary herb garden planted next to the Little Yellow House into a model kitchen garden. Even the desire of the Garden's horticultural staff to conduct research aimed at identifying which native Ohio plants grew best in harsh urban settings was accommodated in a section of the complex devoted to trial beds. The success of The Learning Garden spawned a similar, if smaller satellite campus, Esperanza Garden, on Cleveland's West Side, which became the home base for a second Greens Corps.

All Green Corps interns took entry and exit tests, which consistently demonstrated that the program positively affected their development. Learning Garden manager Maurice Small could also cite anecdotal evidence of his interns' personal growth. "Working in The Learning Garden helps to make them *sharp*," Small says of Green Corps recruits, pointing to the example of Jahmere Young, who came into the program a typical adolescent. After three summers in the Greens Corps, Young had graduated high school with the ambition of establishing a community farm. Conducting a visitor on a tour of The Learning Garden, the thin, tattooed young man confidently rattled off the names of a succession of early spring flowers whose identities were unknown to his companion. "You should come back this summer and see the hollyhocks," he enthused. "They're quite a sight!" He added: "I'm really more interested in growing vegetables because you can feed people."

With the urban educational program taking solid form, the Garden's plans to build a conservatory inched forward. A preliminary architectural concept was commissioned and judged unsatisfactory. The board retained a new architect, Boston's Graham Gund, who drew inspiration for the structure of what was to become the Eleanor Armstrong Smith Glasshouse from the facets of a crystal. With other capital needs factored in, construction estimates for the project came in at $45 million. An additional $5 million would ultimately be raised for endowment, including gifts that established the Clara DeMallie Sherwin Chair in Education and the Elizabeth Whitney Evans Chair in Garden Therapy.

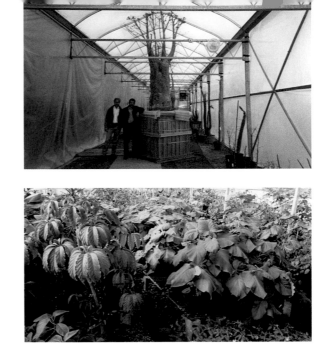

In 1995 development consultants had advised the board that the Garden might not be able to raise much more than $5 million if they plunged directly into fund raising. The decision was made to invest an additional two years in honing the case for support and conferring with potential donors. A dialogue with the trustees of the Kelvin and Eleanor Smith Foundation proved especially productive. The Smith Foundation agreed to provide a $7 million challenge grant, on three conditions. The board must retain professional consultants to evaluate the feasibility of the capital project; confirm the interest of other major potential donors; and contribute a significant percentage of the campaign goal. The board agreed to meet these stipulations, guaranteeing that the capital campaign began on solid footing.

Imported plants destined for the Glasshouse, including the Garden's living baobabs and a host of tropical trees, shrubs and flowers, spent two years in quarantine at an offsite nursery. Working six days a week, it took the Garden's horticulture department more than three months to place and plant 1,500-plus specimens. Technician Joseph D. Mehalik helped to attach epiphytes to the strangler fig.

That it ended in overwhelming success was due to the compelling nature of the Garden's vision and to the conviction, hard work and persistence of board and staff fund raisers. A heroic effort was made, for example, to engage the support of each former trustee of the Garden Center of Greater Cleveland. Lacking even a rudimentary list of past board members, trustee Lauretta M. Dennis sat down to compile one from scratch. She methodically made her way through 65 years of documentation, producing a list of some 400 names. Long-time trustees Elizabeth L. Armington and Margaret B. Marting agreed to co-chair a series of meetings with former board colleagues, at which they were briefed on the Garden's capital plans by Brian Holley. "It's a great compliment to be recognized for a cause to which you have given your time," Marting explains. "People appreciated the opportunity to participate again." All told, the former trustees (now officially recognized as Garden Fellows) contributed more than $6 million to The Campaign for Cleveland's Garden.

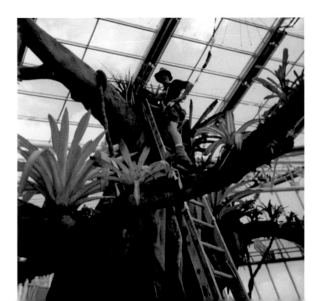

When capital commitments hit the halfway mark, in September 2000 the board decided to proceed with construction "on faith." Work began work in March 2001 under the supervision of Cleveland-based construction manager Donley's, Inc. More than 100 design and construction firms contributed their expertise to the project. By April 2003 the Glasshouse was ready for the creation of the biomes. Working six days a week, horticulture chief Druckenbrod, Glasshouse manager Cynthia Mazer placed and planted

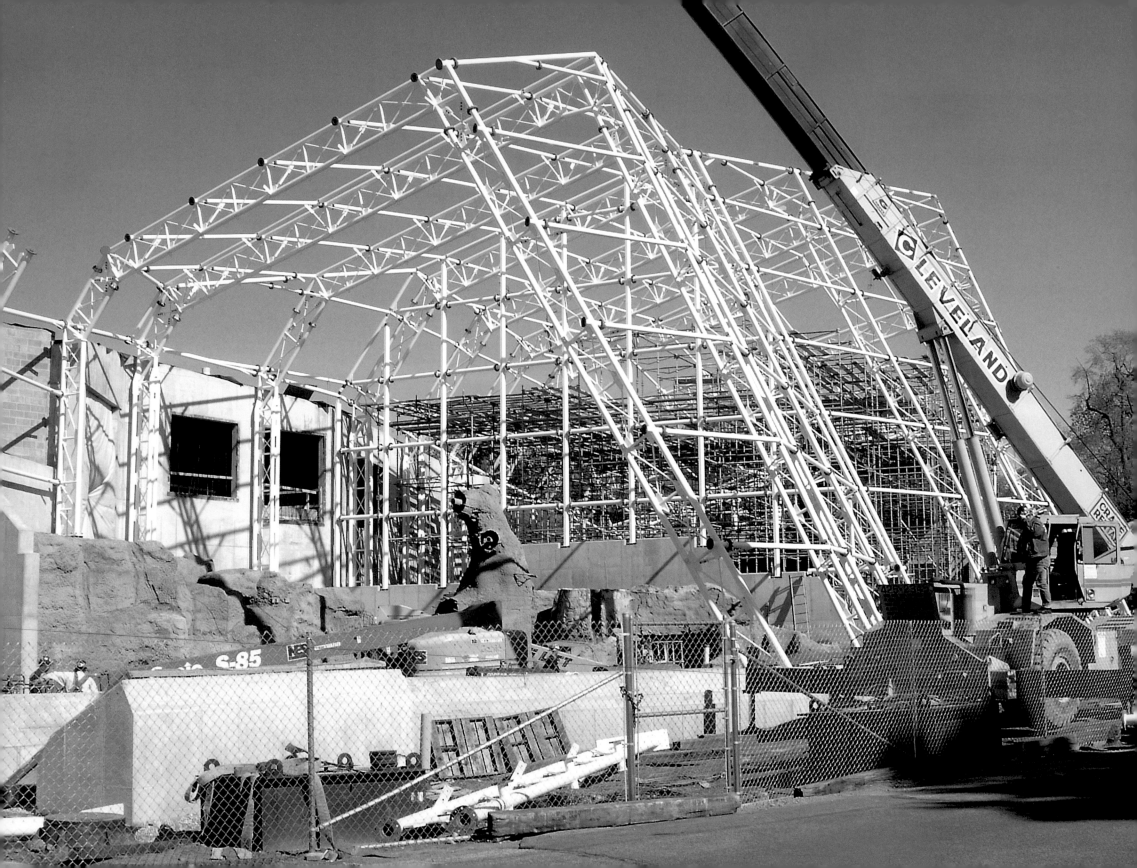

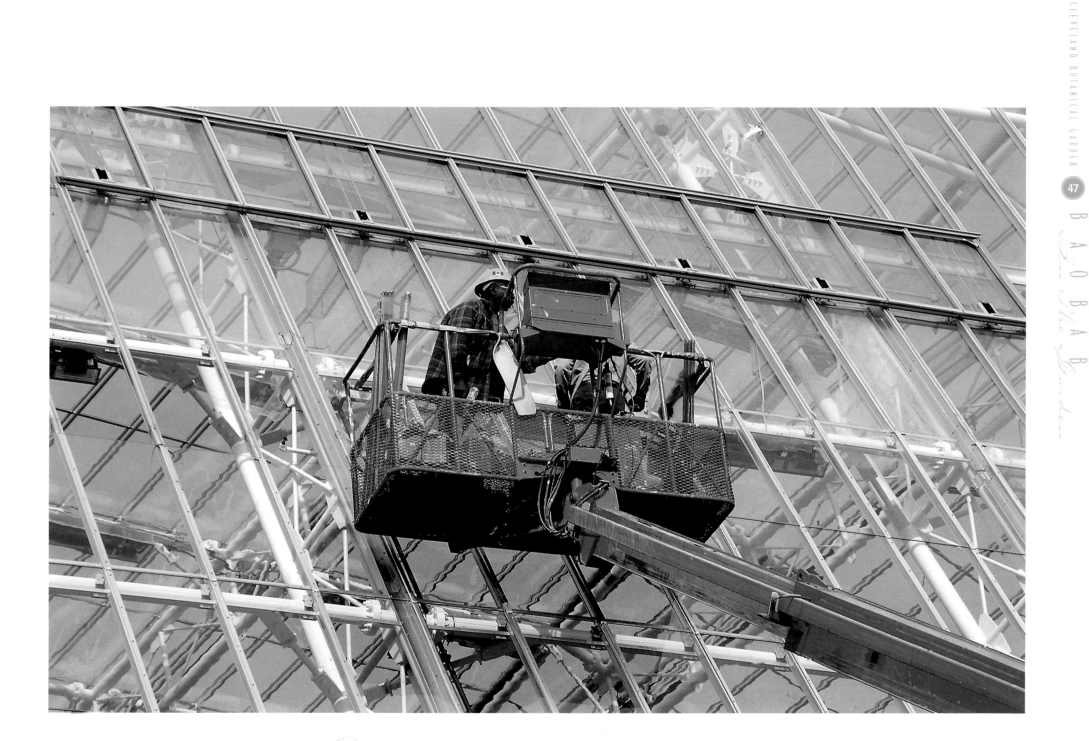

The fabrication of the Glasshouse's framework required 738,123 pounds of structural steel.
Once the framework was erected, workmen set 3,400 individual pieces of glass into place by hand.

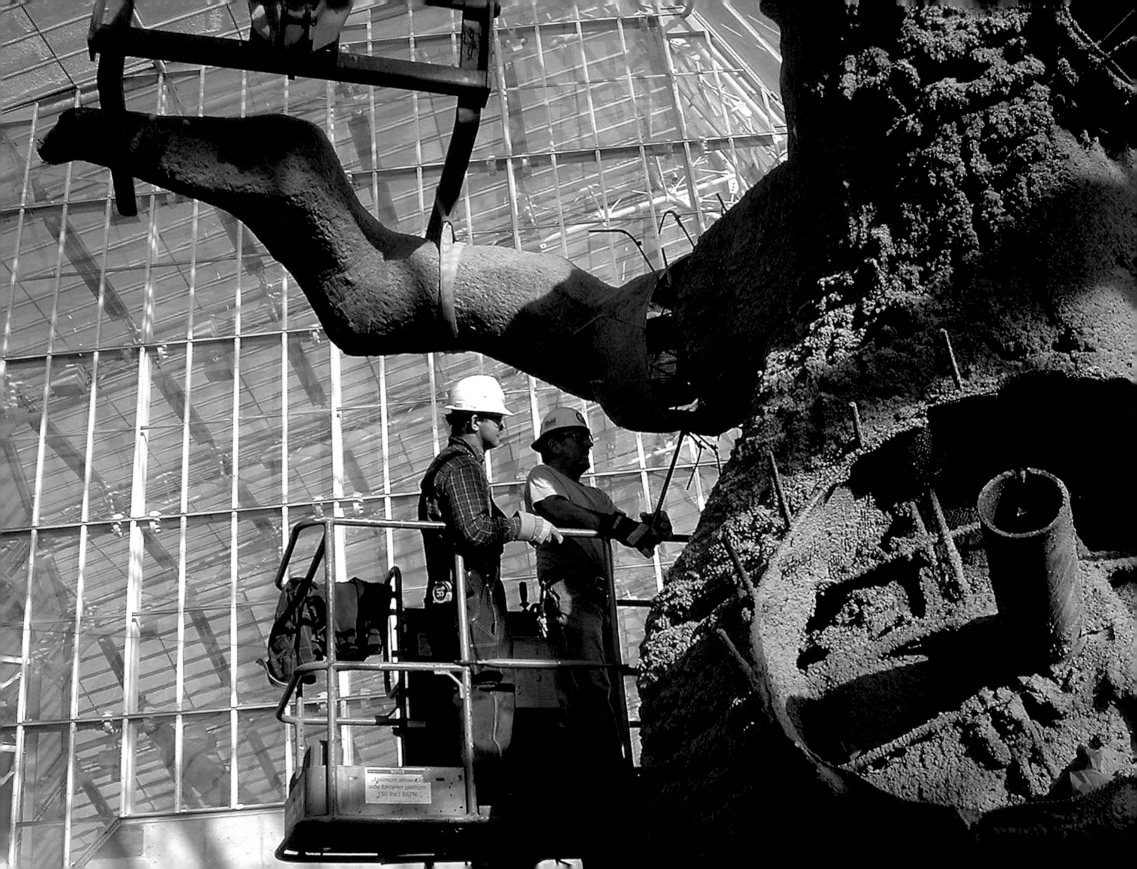

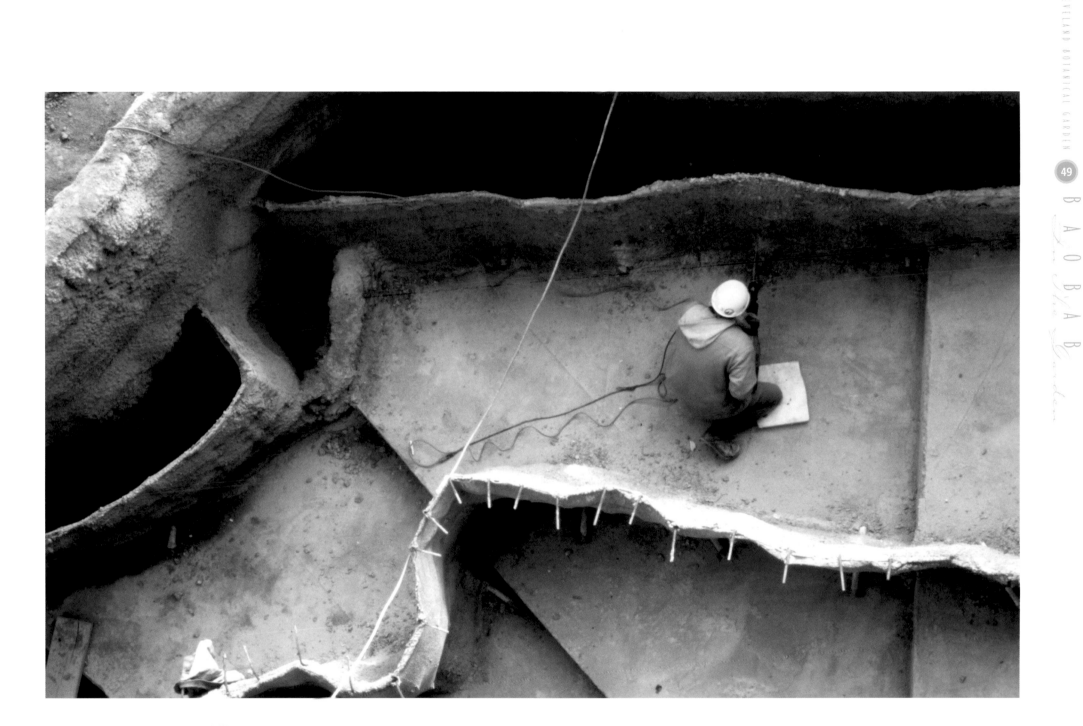

Feats of wizardry: Madagascar's signature baobab and Costa Rica's mountain stream emerge from concrete and steel. More than 100 design and construction firms contributed their expertise to the construction of the Glasshouse, its sophisticated climate-control technology and elaborate infrastructure.

more than 1,500 specimens, with the assistance of Glasshouse technician Joseph D. Mehalik. Mehalik, who had spent a lonely two years tending to the plants during their extended quarantine in an off-site greenhouse, climbed atop a ladder placed on scaffolding that sat on the Costa Rican biome's viewing platform to secure the last bromeliad to the uppermost bough of the "Great Cloud Forest Tree." It was a precarious but joyful topping-out ceremony.

After an 18-month shutdown, Cleveland Botanical Garden reopened in July 2003. Its airy new facility, appointed in mellow woods and pale olive, dusty lilac and teal accents, sat on a campus that had expanded to 10 acres to accommodate several new gardens. These included the David and Paula Swetland Topiary Garden, a work in progress; the C. K. Patrick Garden, a full-sun border; and the Campsey-Stauffer Gateway Garden, a landscaped plaza with a water feature marking the new front entrance of Cleveland Botanical Garden. Open to the public 24 hours a day, the Gateway Garden was intended to be a destination in its own right. If the entry garden succeeded in wooing pedestrians and bicyclists to the area, it might help to foster housing and retail development in the heavily institutional University Circle.

The horticulture staff had seized the opportunity presented by the creation of new gardens to expand the number of worthy but unfamiliar plants to which the public could

be introduced. The enrichment of its holdings would also strengthen the base on which an expanded horticultural research program could be built. Director of horticulture Mark Druckenbrod had worked hard to identify and fill gaps in the collections. For example, he encouraged The Pattie Group, designers of the Gateway Garden, to plant some uncommon ornamental trees. The landscaping firm called for paperbark maple, American yellowwood and weeping Persian ironwood to be interspersed with a selection of historic Ohio oaks (white, swamp and shingle), creating an urban woodland under-planted with flowering shrubs and dwarf, contorted and variegated evergreens. In the Woodland Garden, a living museum of the three major forest types found in Ohio, some exotic "cousins" of native species had been seamlessly introduced at the suggestion of Brian Holley. The presence of counterpart species from other continents—Asian redbud, weeping European beech, Asian spicebush and Japanese jack-in-the-pulpit, to name but a few—made for a fascinating showcase of the phenomenon of parallel evolution.

As of 2004 the Garden's plant collections numbered about 2,300 species and cultivars in 500 genera. Approximately one third of the specimens had been added over the previous 36 months. Druckenbrod regarded the expansion of the botanical garden's plant holdings as his proudest professional accomplishment to date, in that it had increased the institution's potential to contribute to scientific knowledge as well as to educate public taste. The work of the Garden's new curator of collections, Ann E. McCulloh,

A $45 million capital campaign made possible the creation of several new gardens, including the Elizabeth and Nona Evans Restorative Garden and those featured on pages 52 through 55.

DAVID AND PAULA SWET

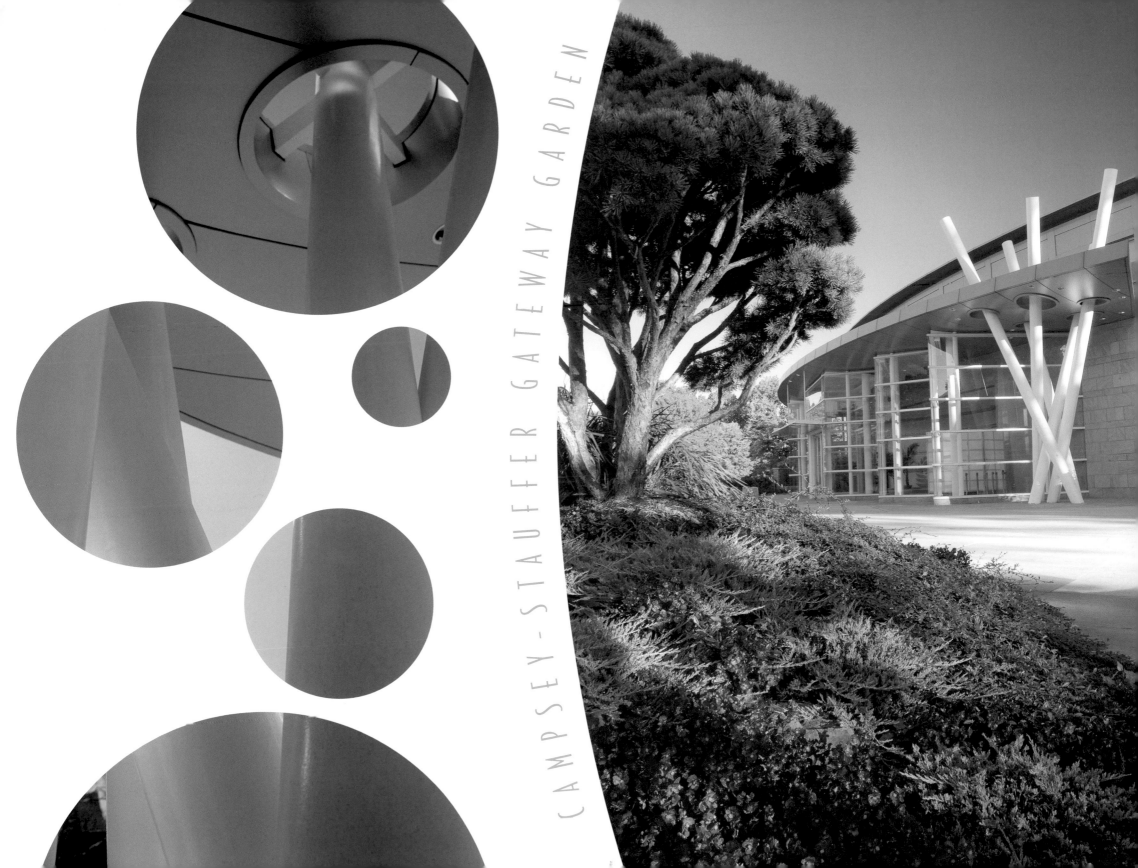

CAMPSEY-STAUFFER GATEWAY GARDEN

BAOBAB *In The Garden*

complemented the horticultural department's efforts. McCulloh had begun to catalogue the entire collection, a mammoth initiative on which future advancements in research and interpretation depended.

The dedication of the Eleanor Armstrong Glasshouse on July 15, 2003, gave the staff and board a chance to breath a "collective sigh," according to Garden vice president Jennifer Coleman Fluker, an architect who served on the project oversight committee that, with the assistance of owner's representatives Vickie Dahl and Linda Rhodes, brought the Glasshouse in on time and under budget. A beautiful sunny day attended the public ceremony, witnessed by hundreds of Greater Clevelanders. A priest, a rabbi and a minister offered blessings, and other notables, including the mayor of Cleveland, spoke in front of the Louis D. Kacalieff, M.D. Entrance. After the ribbon cutting, the crowd surged into The Reinberger Lobby to purchase tickets to tour the Glasshouse. Ellen Stirn Mavec, the granddaughter of Eleanor Armstrong Smith and president of the Kelvin and Eleanor Smith Foundation, stood at the front door, greeting visitors and enjoying the awed look on their faces.

As oldsters and youngsters entered the ellipse on their way to the Glasshouse for what may have been their first sight of a live baobab, they passed under an archway bearing a pithy inscription. The motto captured the universality of Cleveland Botanical Garden's appeal. It said:

*Plant a Seed * Celebrate Life.*

New visitor amenities include underground parking, an elliptical atrium offering a spectacular view into the Madagascar biome, a café and a modern gift shop.

GARDENS

Gardens
Clark Hall
Café
Library
Education Wing

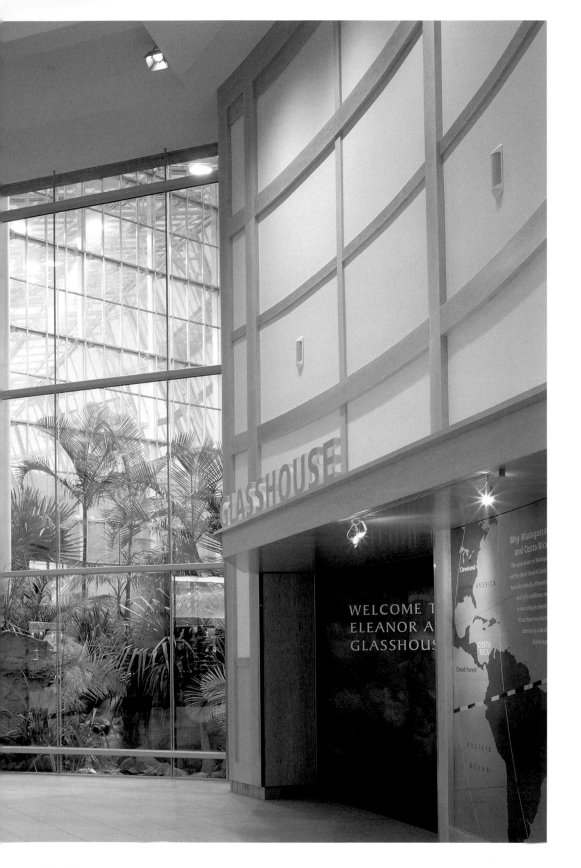

The stylized leaf shapes of the Donna M. and Stewart A. Kohl Gate (seen here in a detail and on the following pages *in situ*) evoke the fantastical forms of the Glasshouse's plants. Installed in 2004, the sculptural gate is the creation of master metal artist Albert Paley of Rochester, New York.

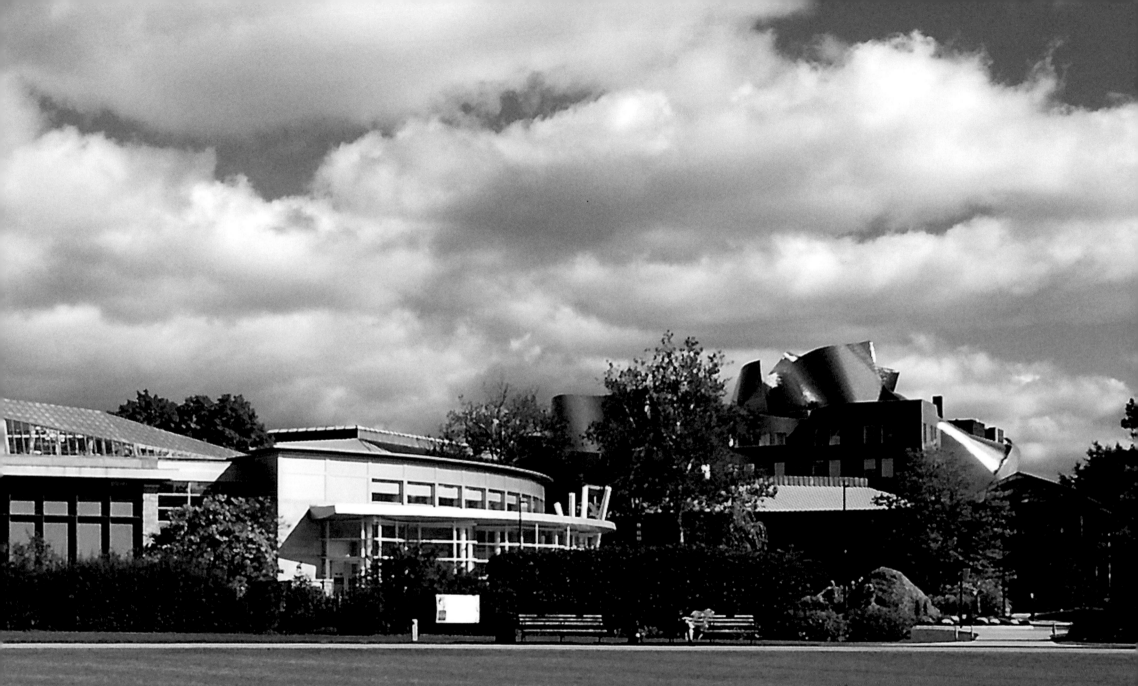

Cleveland Botanical Garden, as viewed from Wade Oval. The Garden's urban "skyline" engages in a spirited conversation with the Peter B. Lewis Building of the Weatherhead School of Management, designed by internationally acclaimed architect Frank Gehry, on the campus of Case Western Reserve University, to the right.

Madagascar. Costa Rica. The names alone conjure images of exotic climes populated by wonderfully strange plants and animals. To be transported to these contrasting realms of arid heat and misty verdure requires a trip of only a few steps into the Eleanor Armstrong Smith Glasshouse. In Cleveland Botanical Garden's deft hands, re-creations of a Costa Rican cloud forest and the Madagascan spiny desert are lands of 1,001 enchantments. Glinting like jewels, neon-colored butterflies flit here, there and everywhere in the Costa Rican forest. Desiccated sticks and stalks sprout exuberant foliage and delicate blossoms during the Madagascan "wet" season. These are living panoramas of the dramatic ways in which plants, animals and humans adapt to differing conditions of water and light. Prepare to be amazed.

LANDS OF

ENCHANTMENT

A N

Male and female Oustalet's chameleons (*Furcifer oustaleti*) roam freely in the Madagascar biome, charming young and old alike. The mating pair belongs to the world's largest species of chameleon.

It's hard to believe that both the thorny *Alluaudia comosa* and the flowering periwinkle (*Catharanthus roseus*) thrive in the semi-arid desert of Madagascar, an island off the west coast of Africa.

MADA

GASCAR

The Madagascar biome features four true-to-life habitats. (Left) Sandstone cliffs representing the Isalo Massif of southwestern Madagascar ring a lush desert oasis. (Right) On the Isalo "plateau," the bizarre forms of pachypodium (center), aloe (lower right) and euphorbia (upper right) call to mind a Dr. Seuss landscape.

Madagascar's lesser hedgehog tenrec (*Echinops telfairi*) typically spends his days sleeping, allowing visitors a chance to study the animal believed to be the closest living relative to the first mammals on earth.

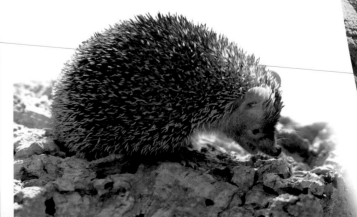

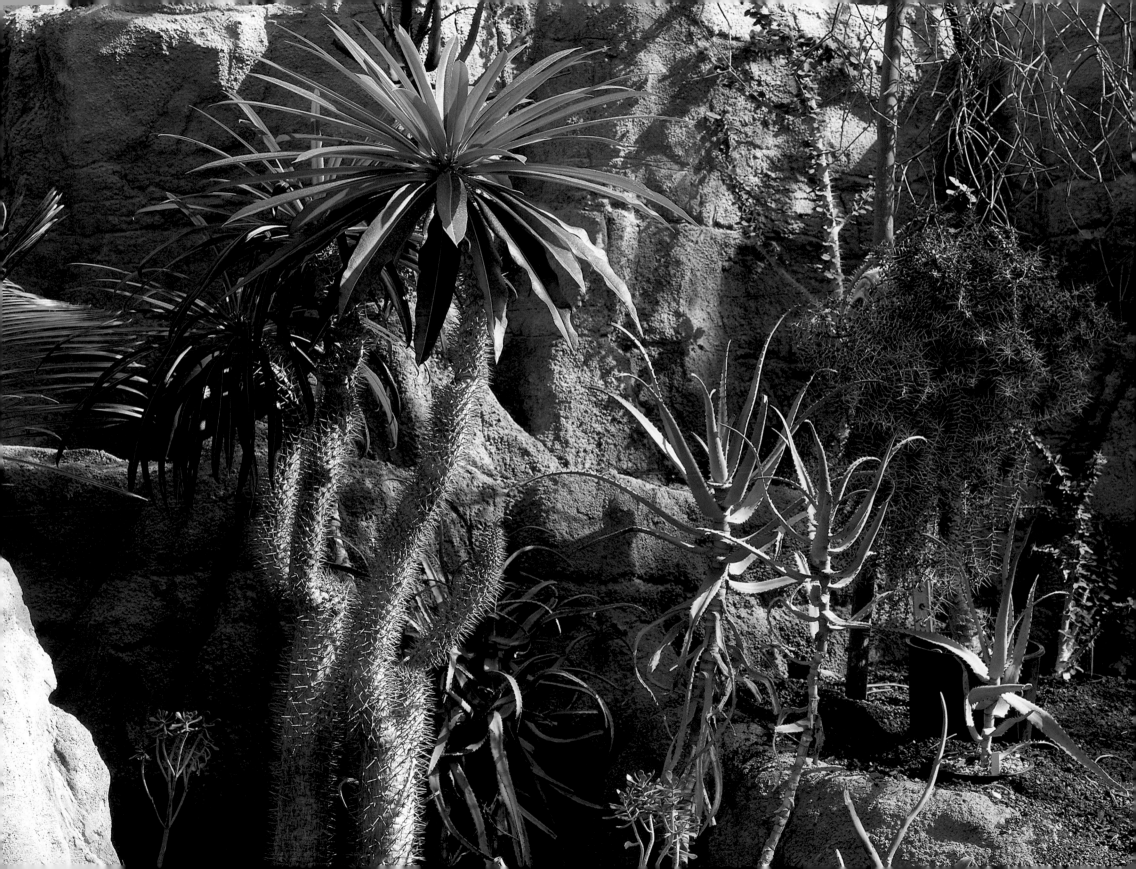

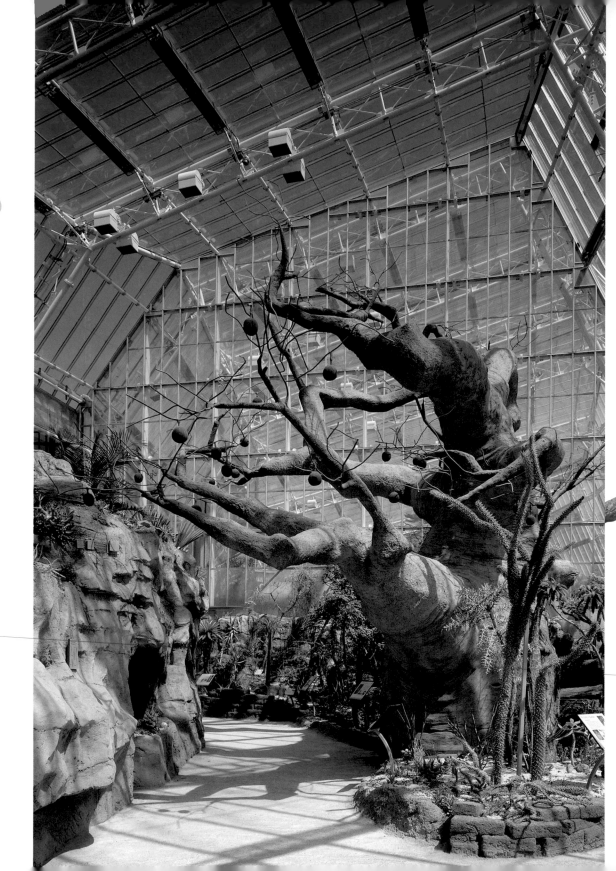

The biome's spiny forest is home to one of the largest collection of Madagascan baobabs in the United States. Five living examples represent two of the six species found on the island. A 30-foot-tall recreation of a mature *Adansonia za* impresses with its massive girth and hard-shelled fruit.

Demonstrating the incredible adaptability of plants, periwinkle and aloe (with the pink and peachy blooms, respectively) flourish in the tiny crevices of the Isalo cliffs.

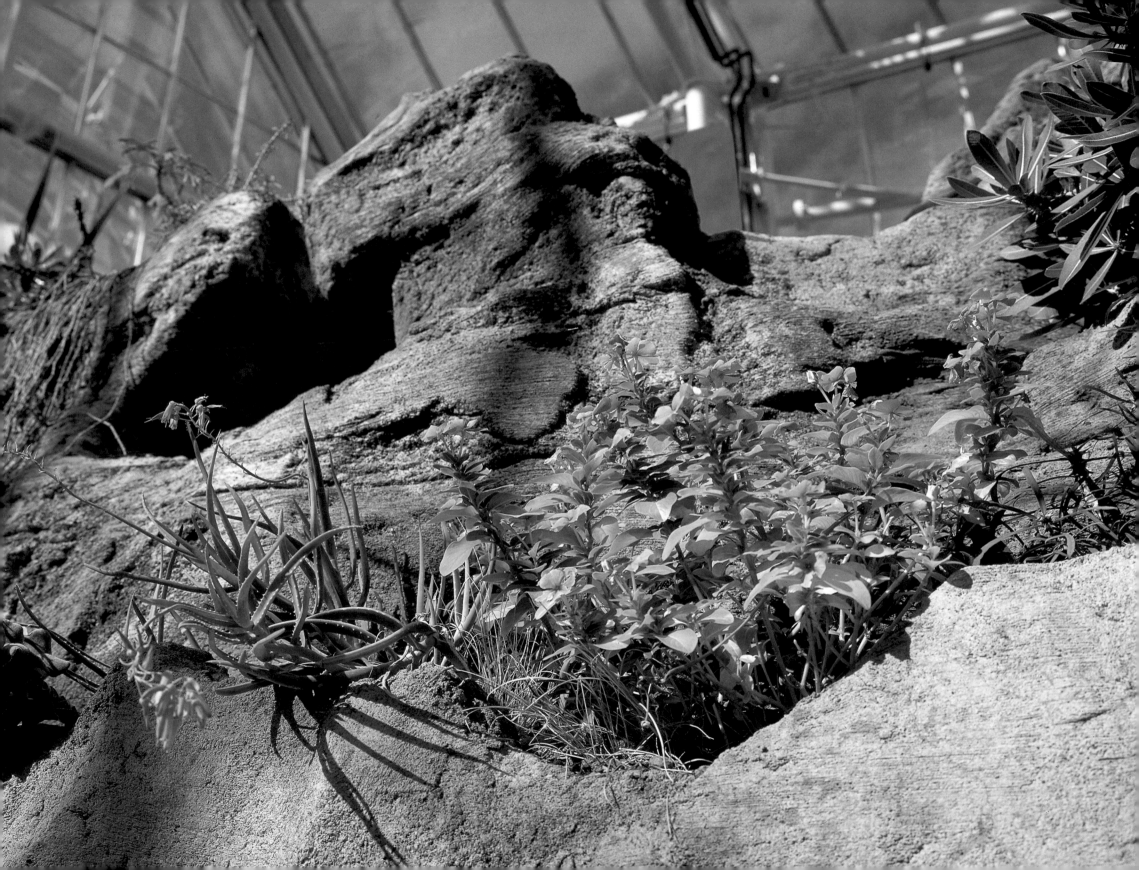

A*lluaudia comosa*'s thorns ward off predators and retard water evaporation. Despite its prickly appearance, *Alluaudia* is not a cactus—nor, for that matter, are any of Madagascar's desert-dwelling plants.

o u c h

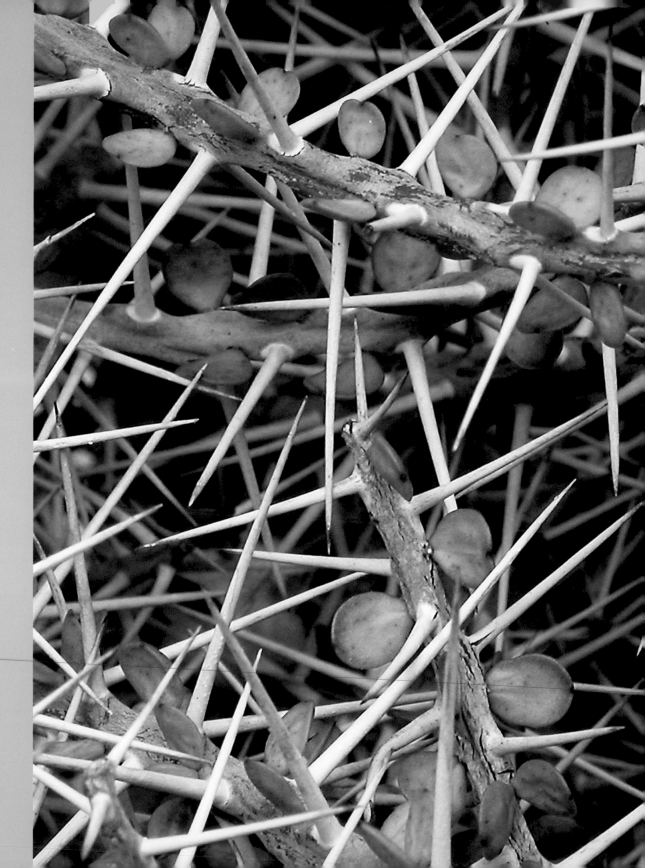

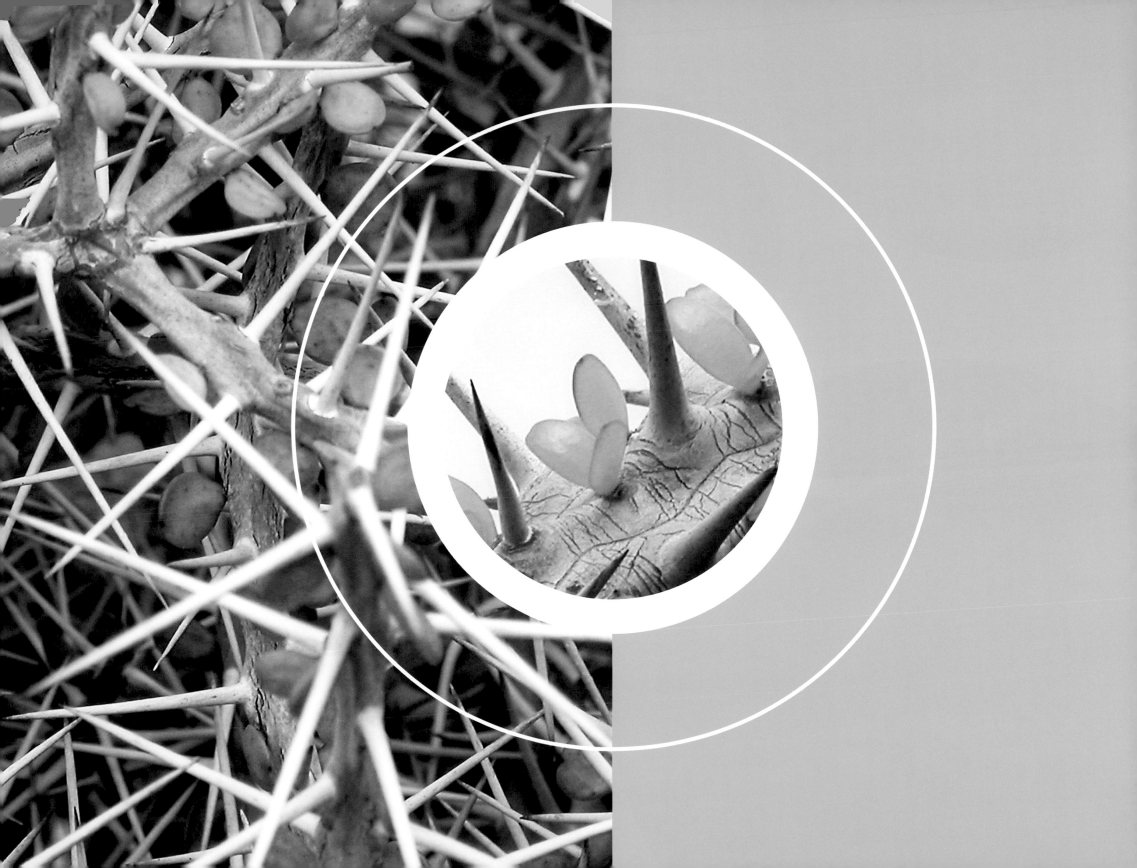

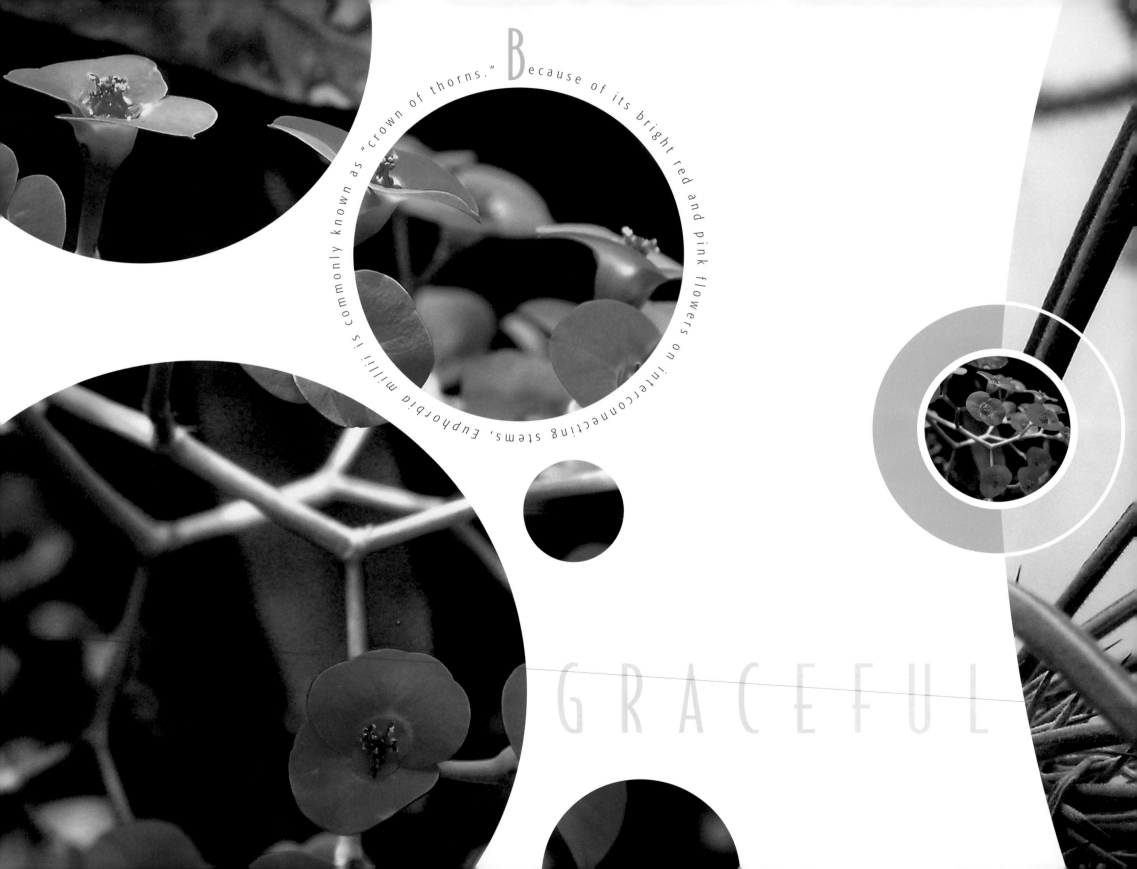

Because of its bright red and pink flowers on interconnecting stems, Euphorbia milii is commonly known as "crown of thorns."

GRACEFUL

The graceful, curling leaves of *Pachypodium geayi* mimic wrought iron. Many pachypodium species are known for their ornamental displays.

Plant! This is the tuber (right) of the Turtle-back yam (*Dioscorea elephantipes*). Yams are a dietary staple of the Malagasy people. (Below and inset) The Garden's radiated tortoise (*Geochelone radiata*), a native of Madagascar, is widely admired for the colorful "starring" on its high-domed shell. When fully grown, this one may reach 16 inches in length.

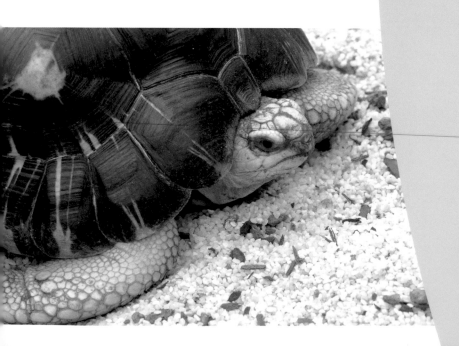

PLANT or ... ANIMAL?

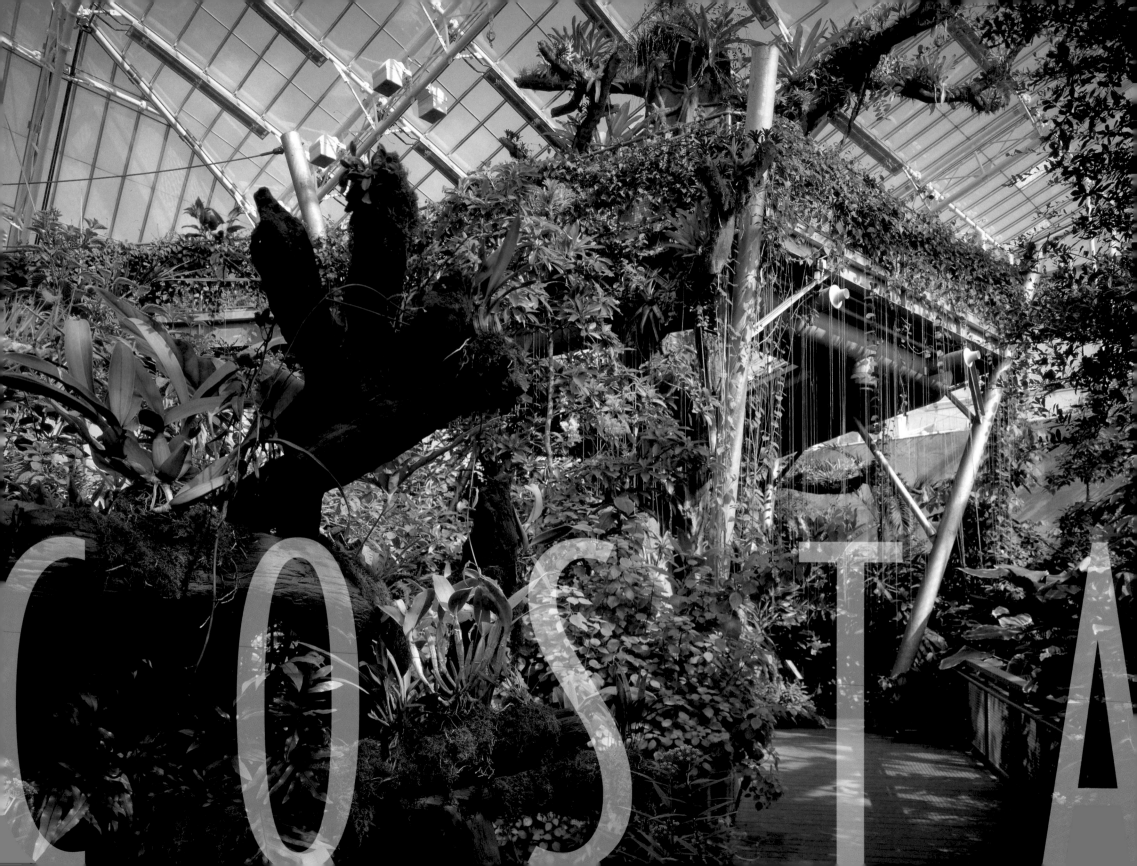

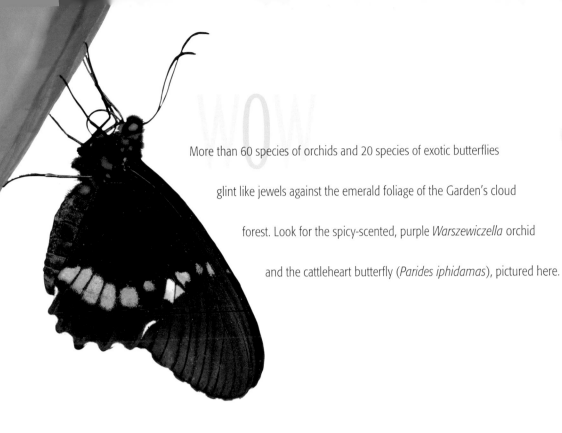

More than 60 species of orchids and 20 species of exotic butterflies

glint like jewels against the emerald foliage of the Garden's cloud

forest. Look for the spicy-scented, purple *Warszewiczella* orchid

and the cattleheart butterfly (*Parides iphidamas*), pictured here.

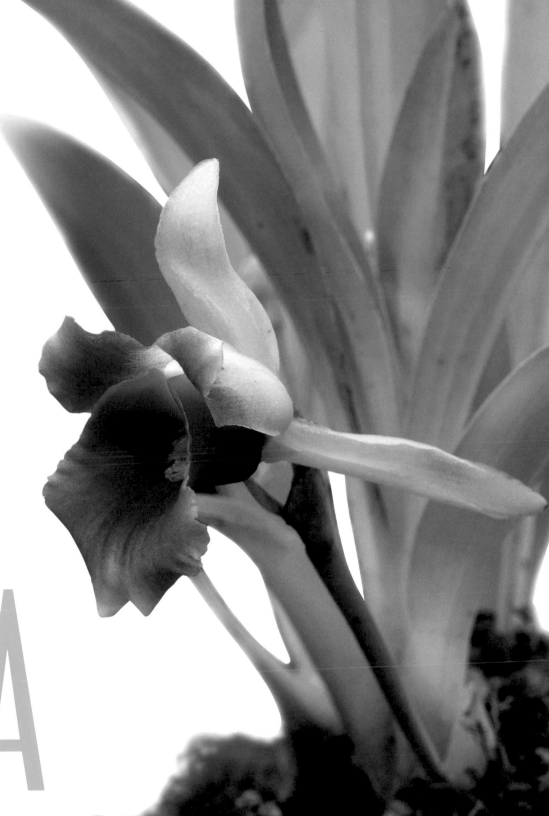

Visitors to the Costa Rica biome are immersed in the otherworldly beauty of a cloud forest, one of the planet's most threatened environments. Winding paths permit up-close exploration of the lush, tropical understory and lead to a two-story platform offering a bird's-eye view of the canopy.

RiCA

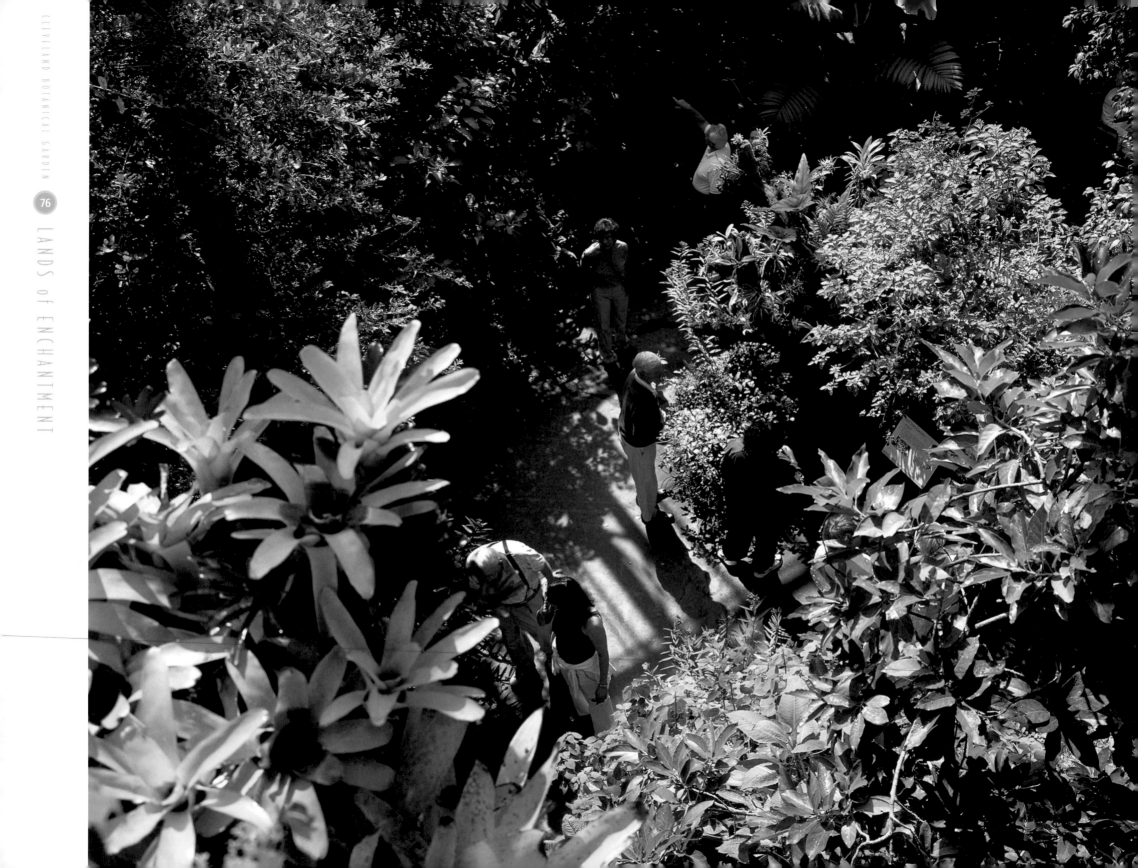

Make new friends: The sleepy mallow (*Malvaviscus arboreus*), which bears a resemblance to its more familiar relative, the hibiscus, is so named because the mallow's blossoms never fully open.

The uppermost branches of the biome's signature strangler fig tree support a profusion of bromeliads, such as the red-tipped *Aechmea* and red-centered *Neoregelia* pictured at lower left. Bromeliads are fascinating examples of epiphytes: plants that grow on other plants.

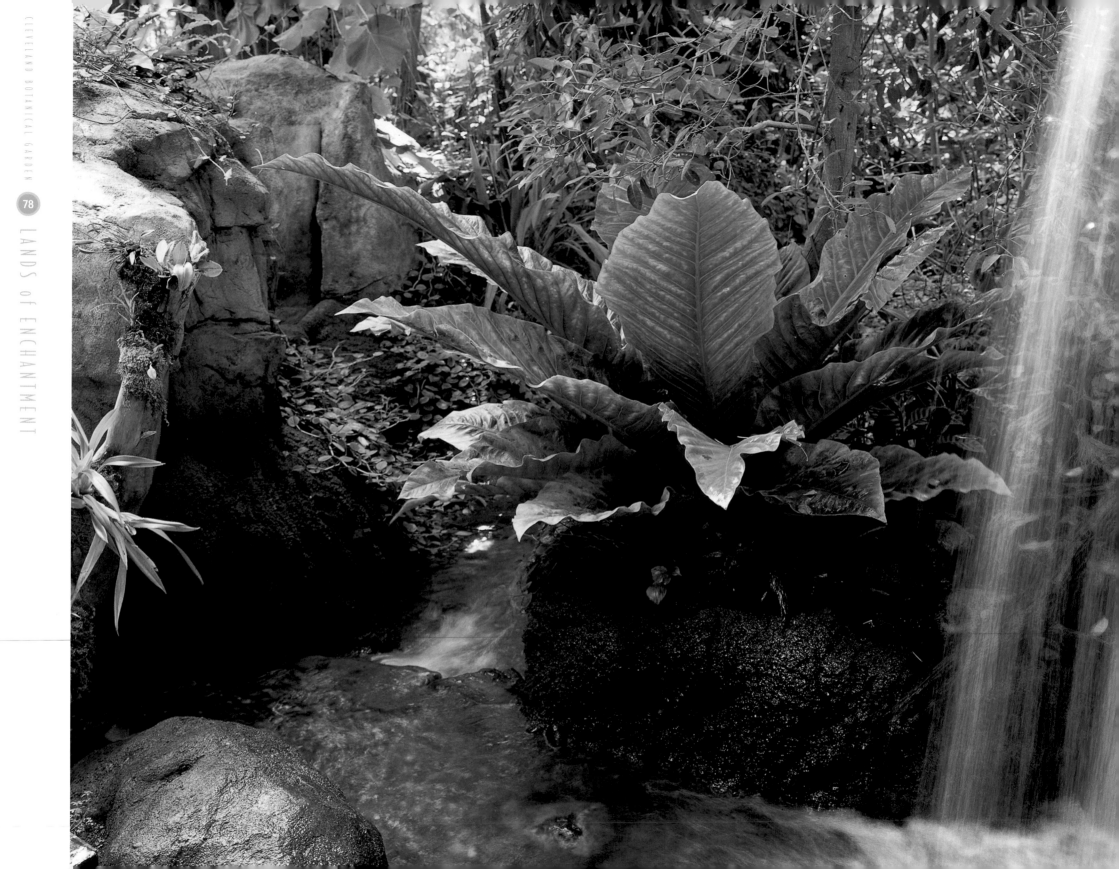

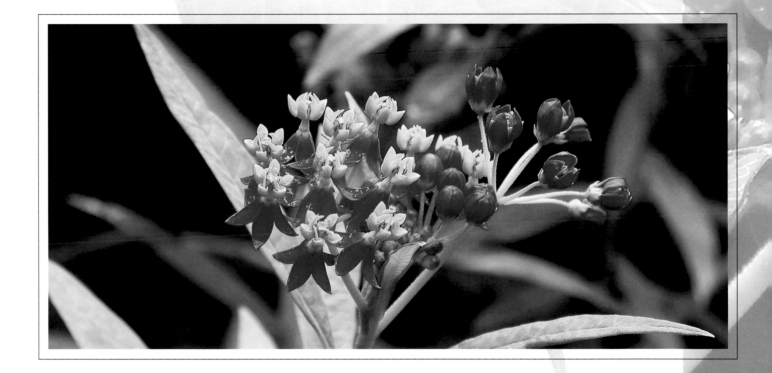

Popular attractions in their own right, a waterfall and rushing mountain stream replicate one of the micro-habitats preferred by a giant *Anthurium salvinii*. This plant, which can reach 12 feet in diameter, can also grow in trees. The red-and-yellow flowers of tropical milkweed (*Asclepias currasavica*) can be spotted throughout the Costa Rica biome; butterflies are especially fond of its nectar.

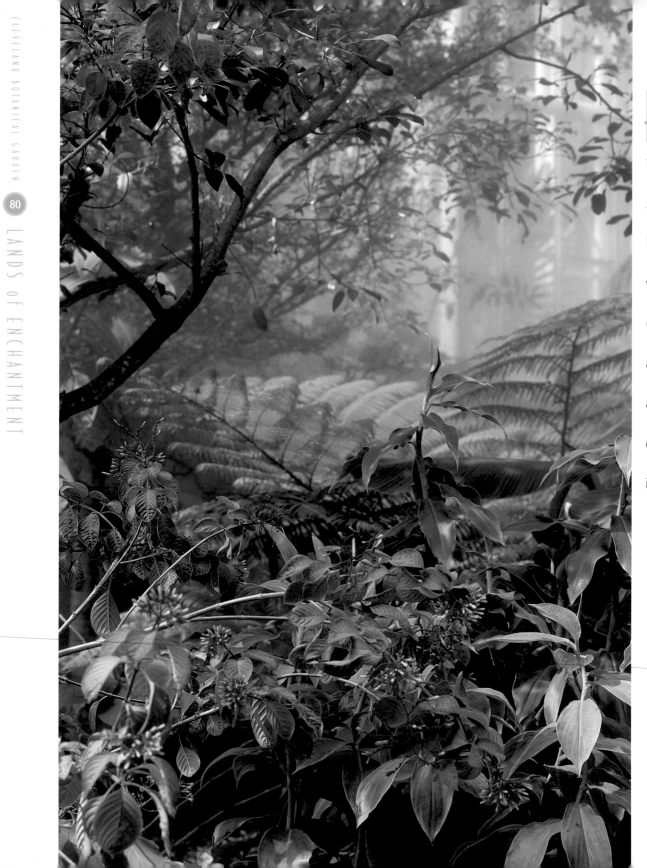

Firebush (*Hamelia patens*), named for its flame-colored flowers, crowds out a spiral ginger (*Costus* sp.), with the smooth green leaves on the right, in their race to reach water and light. The towering tree fern (*Cyathea cooperi*) in the background and the fig tree at the upper left enjoy a head start. (Below) The leaves of the cecropia tree can grow to two feet in diameter.

The scarlet-red undersides

of the leaves of a

Begonia multinervia

reward close

inspection.

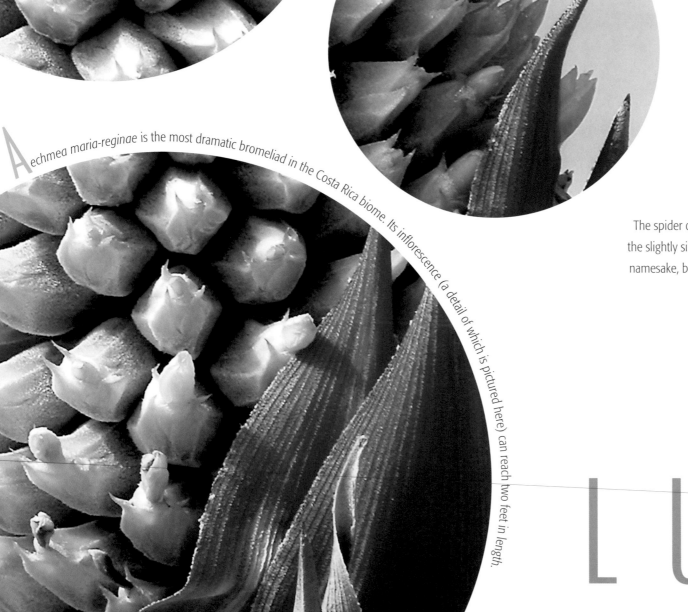

Aechmea maria-reginae is the most dramatic bromeliad in the Costa Rica biome. Its inflorescence (a detail of which is pictured here) can reach two feet in length.

The spider orchid (*Brassia* Rex) has the slightly sinister appearance of its namesake, but is amazingly fragrant.

LUSH L

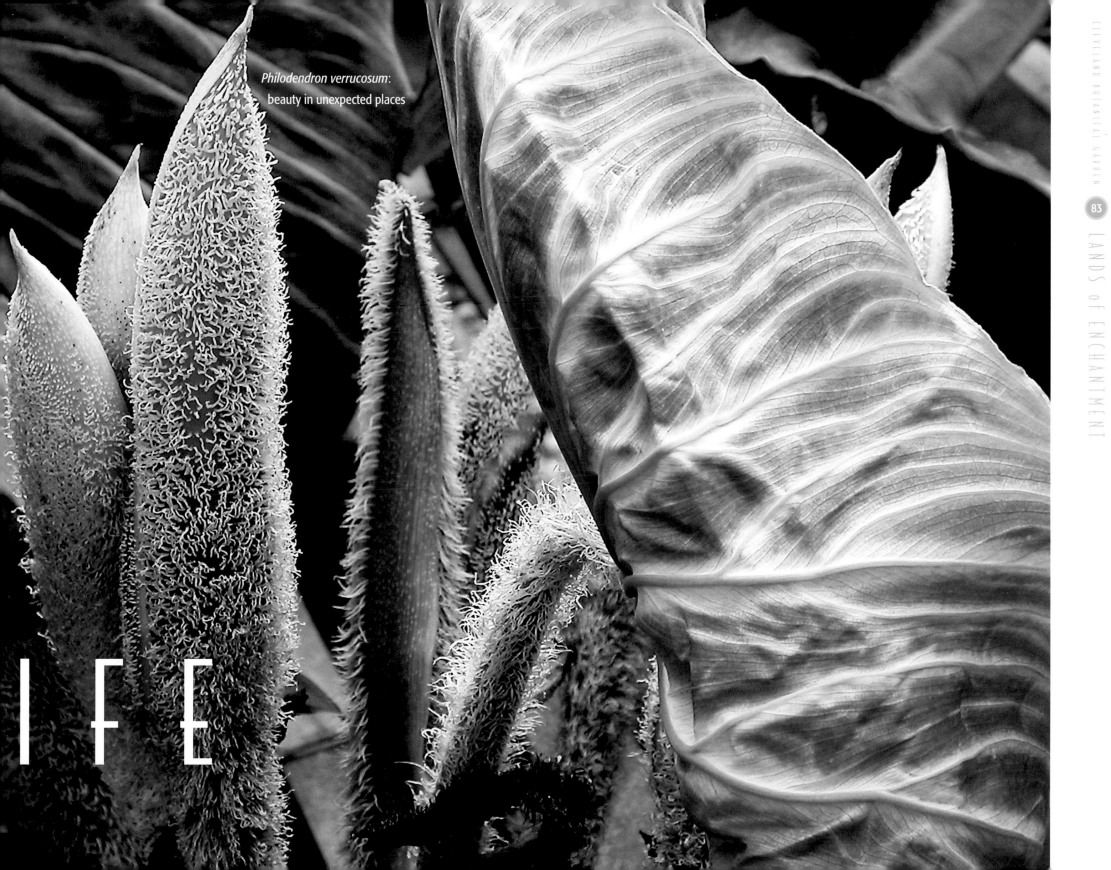

Philodendron verrucosum:
beauty in unexpected places

IFE

Costa Rica boasts one of the world's greatest diversity of orchids. The Garden's collection offers a rich sampling: (below) *Maxillaria tenuifolia*, with its intense fragrance of coconut; (center left) spidery *Brassia* Rex, set off dramatically by scarlet bromeliads (*Neoregelia* 'Fireball'); (center right), *Brassavola nodosa*, known as "lady of the night"; (upper right), waxy-textured *Encyclia chacoensis*; and (lower right) *Cattleya skinneri*, Costa Rica's national flower.

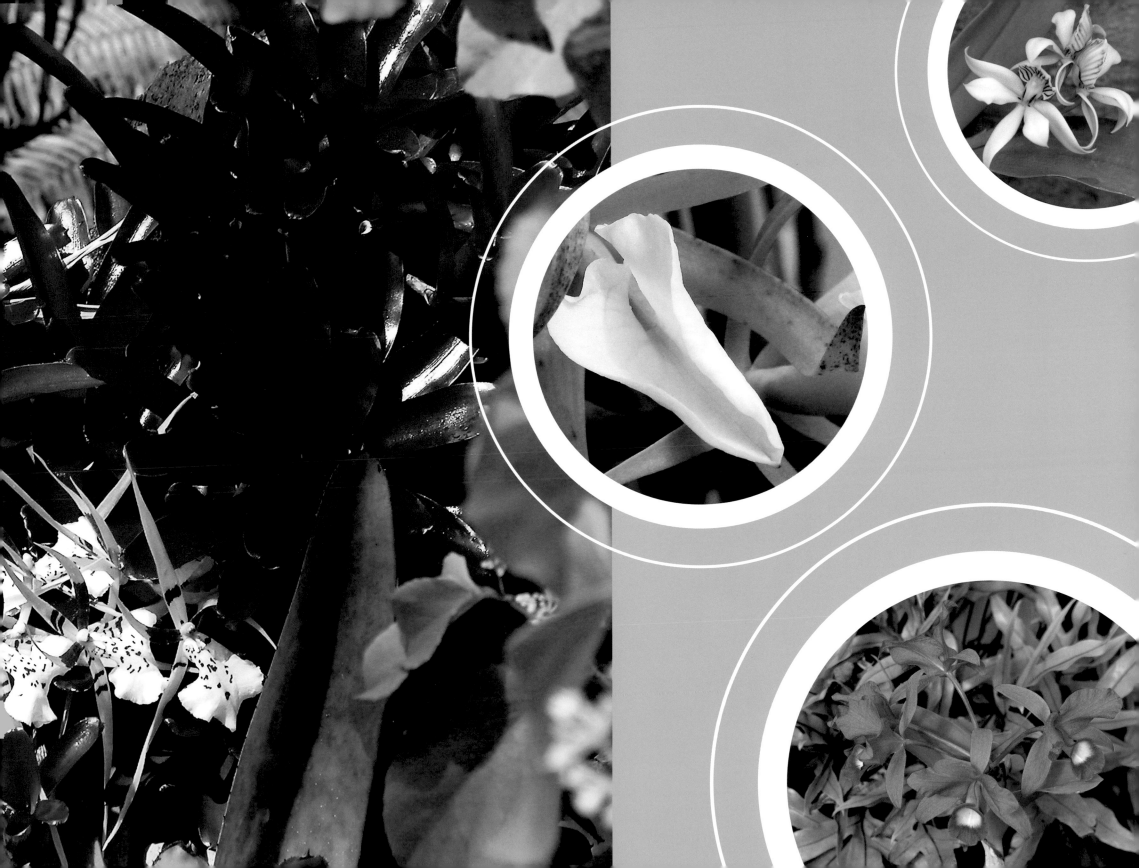

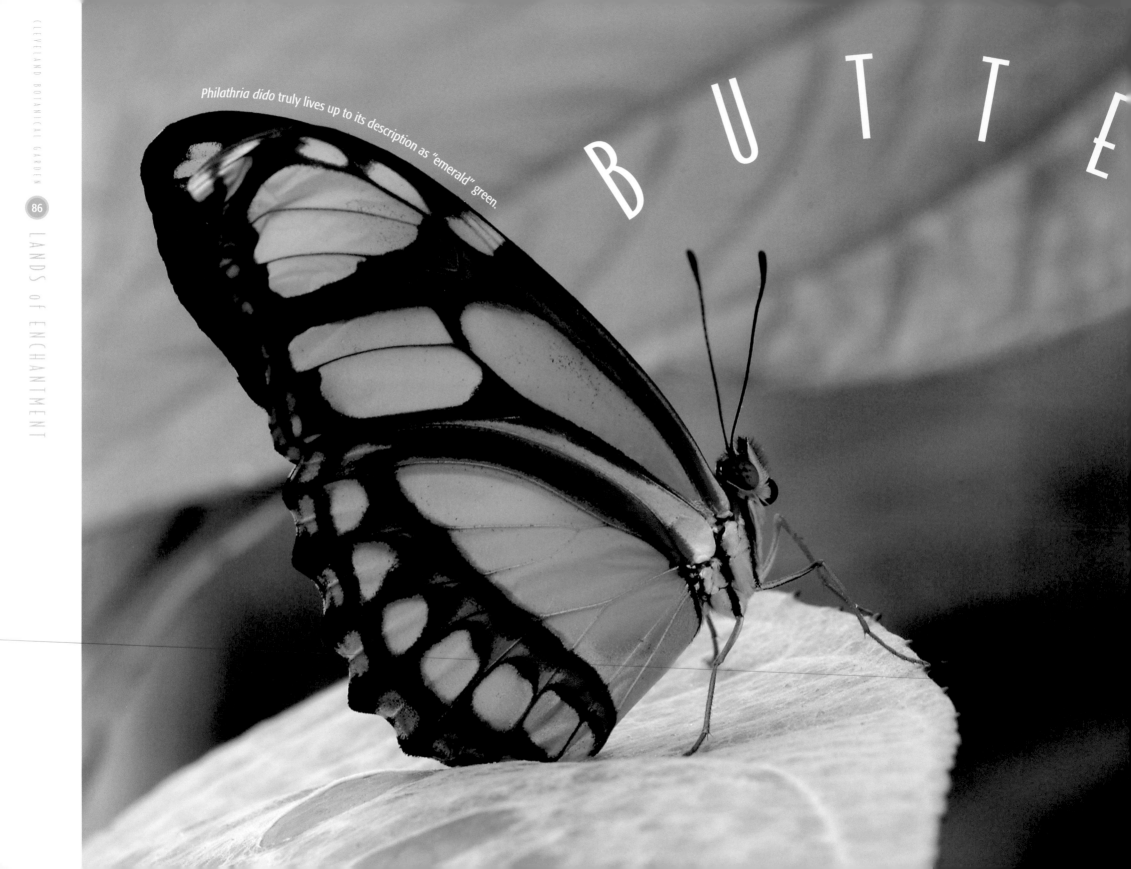

BUTTE

Philathria dido truly lives up to its description as "emerald" green.

R F L I E S

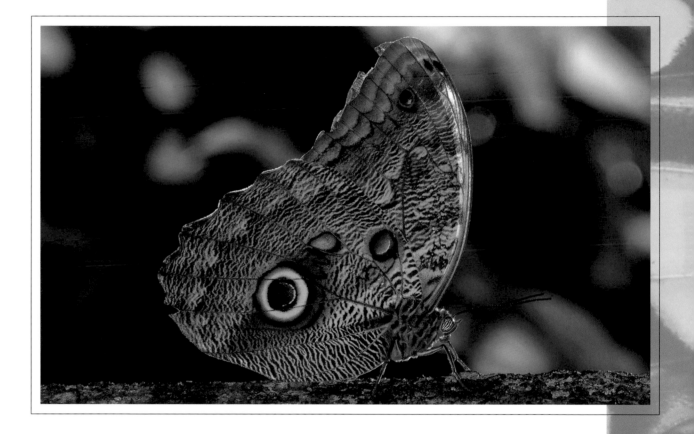

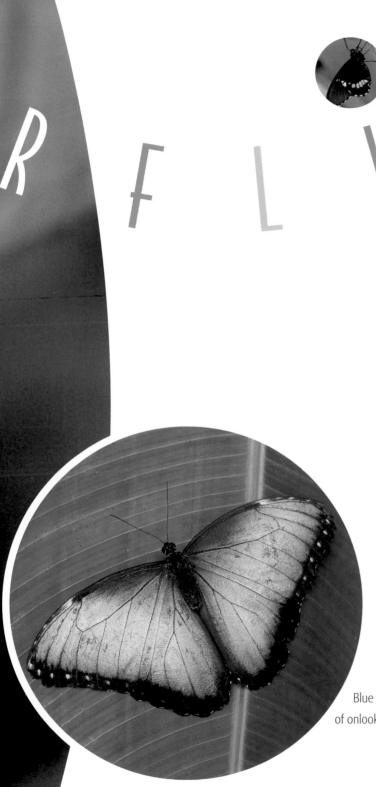

Blue Morphos (*Morpho peleides*) are the kings of the cloud forest. To the delight of onlookers, they often chase one another along the mountain stream in the biome.

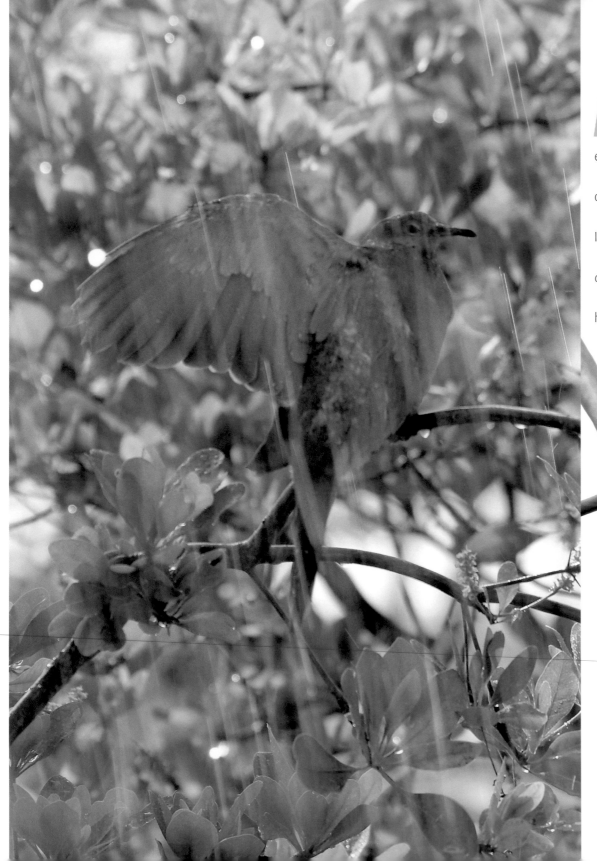

A white-wing dove (*Zenaida asiatica*)

enjoys a light shower during one

of the biome's frequent mistings.

Its brilliant blue and black sheens

distinguish the male red-legged

honeycreeper (*Cyaneus cyanerpes*)

from the greenish female.

A lone

dove feather rests lightly

on a sage plant (*Salvia polystachya*). The

eight species of birds in the Costa Rica biome feel so at home,

some have begun to nest and produce offspring.

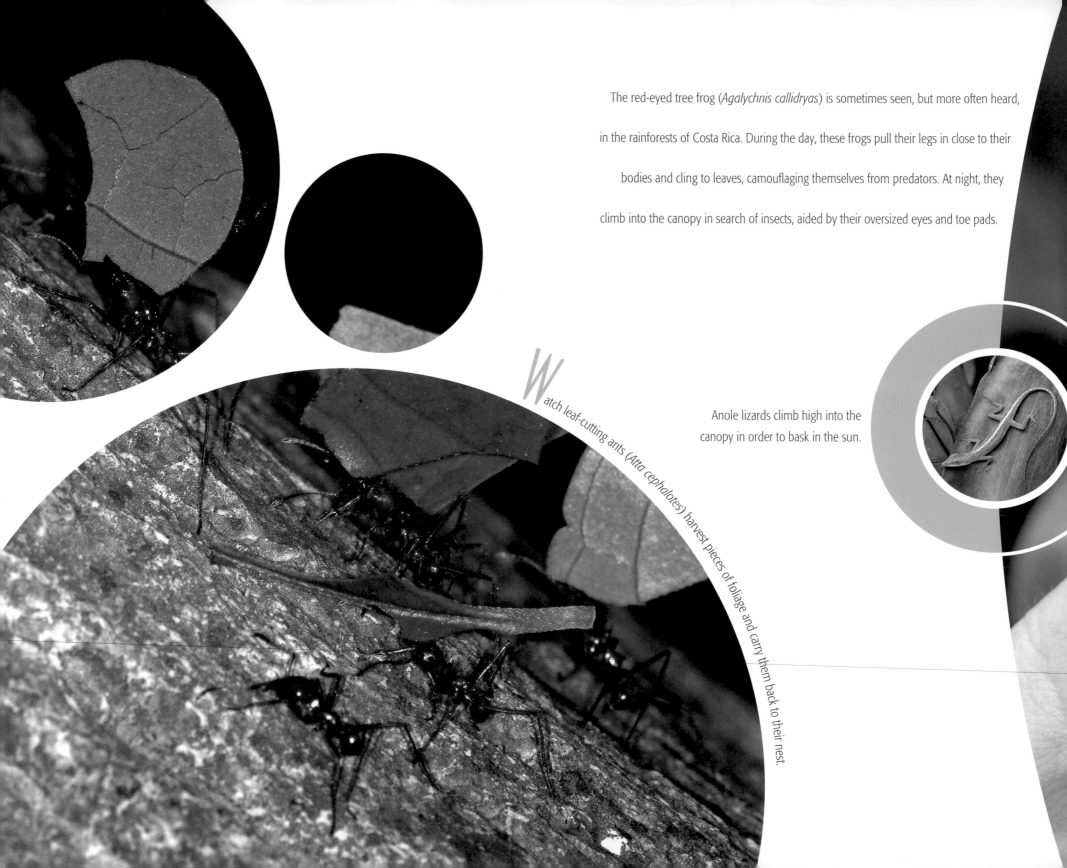

The red-eyed tree frog (*Agalychnis callidryas*) is sometimes seen, but more often heard, in the rainforests of Costa Rica. During the day, these frogs pull their legs in close to their bodies and cling to leaves, camouflaging themselves from predators. At night, they climb into the canopy in search of insects, aided by their oversized eyes and toe pads.

Anole lizards climb high into the canopy in order to bask in the sun.

Watch leaf-cutting ants (*Atta cephalotes*) harvest pieces of foliage and carry them back to their nest.

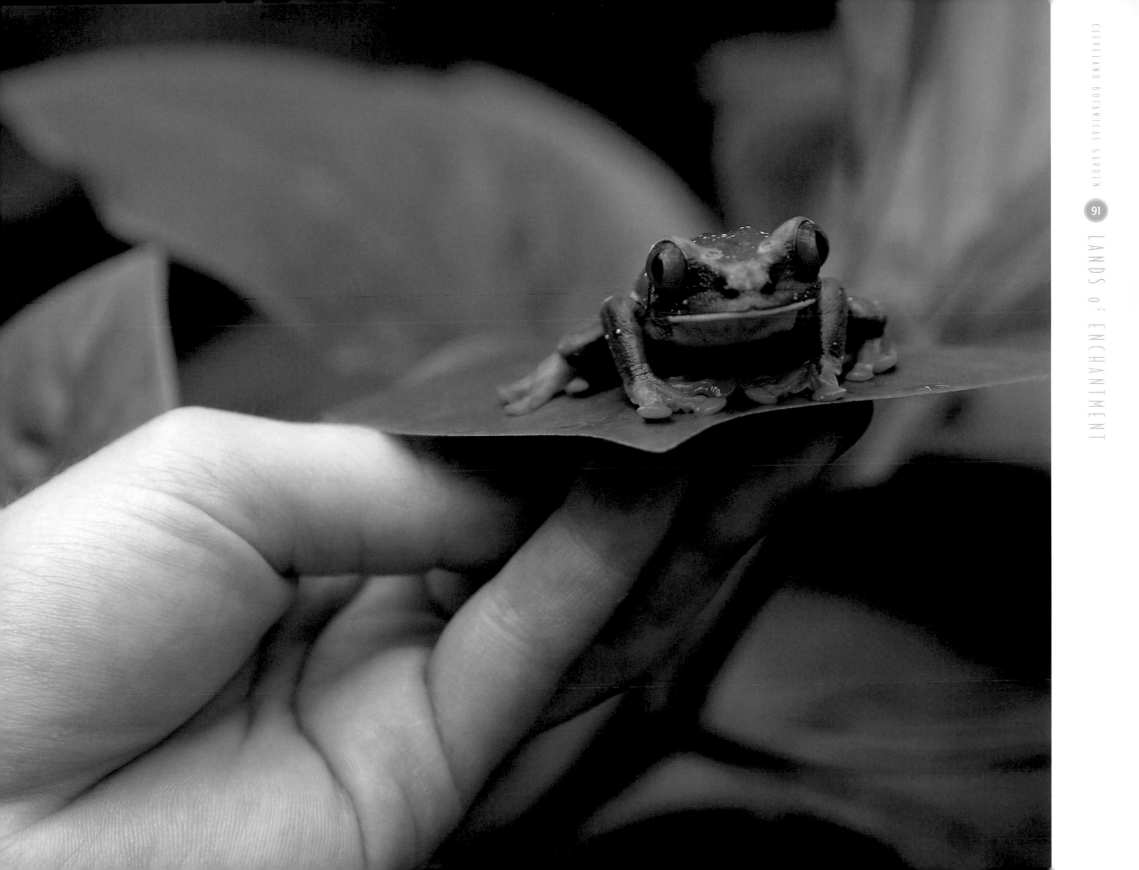

Imagine a garden designed specifically to educate and entertain children. You enter through a wrought iron-gate bedecked with friendly bugs

and butterflies. A sundial with a bronze sun face spouting playful arcs of water greets you. There are rocks to climb, hills to roll down and

a pond in which to hunt for tadpoles. At the end of a woodland path, a gigantic tree house overlooks a fantastical landscape of meadows,

farmland and gardens. Nature in all its splendid guises awaits discovery. Kids can independently explore the amazing diversity of plant life,

take a simple gardening class or participate in a seasonally themed special event. Welcome to Hershey Children's

Garden, designed by the award-winning landscape architect Herbert. R. Schaal, in consultation

with Cleveland Botanical Garden staff and trustees and

groups of Cleveland schoolchildren.

Best Little

Classroom in Ohio

A plaque featuring a quotation from famed horticulturist Luther Burbank welcomes visitors to Hershey Children's Garden. It reads: "Every child should have mud pies, grasshoppers, waterbugs, tadpoles, frogs, mud turtles, elderberries, wild strawberries, acorns, chestnuts, trees to climb, brooks to wade, water lilies, woodchucks, bats, bees, butterflies, various animals to pet, hayfields, pine-cones, rocks to roll, sand, snakes, huckleberries and hornets, and any child who has been deprived of these has been deprived of the best part of . . .education."

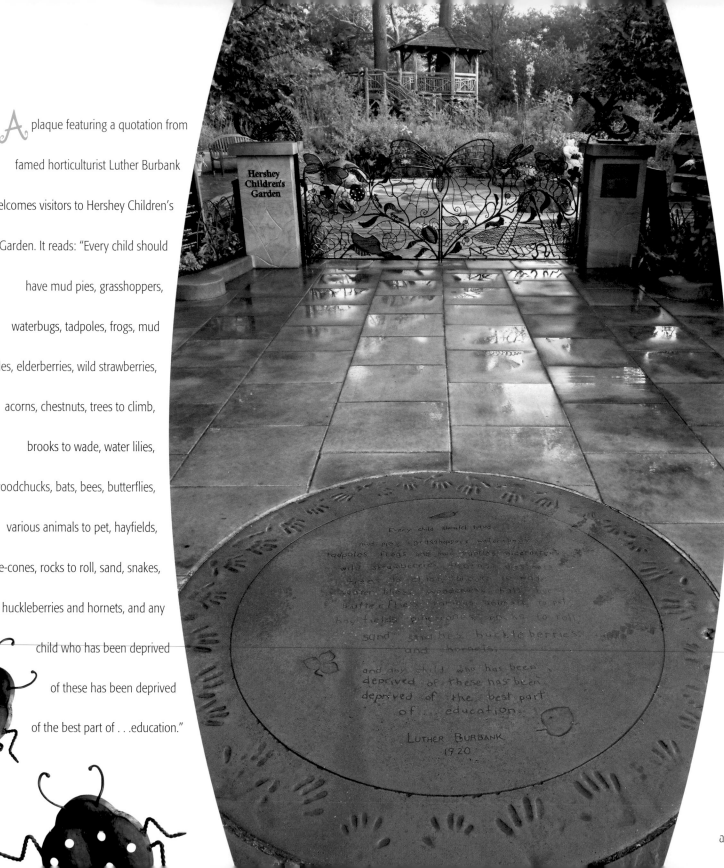

Come on in

Garden trustee and benefactor Debra Guren Hershey advocated for the garden's child-friendly scale and fanciful touches. The prairie house is pint-sized and its sod roof sprouts tickseed; the door to a tool shed is a fun work of art. Purple clematis and lime-tinged lovage (an herb in the carrot family) are a color combination any kid could love.

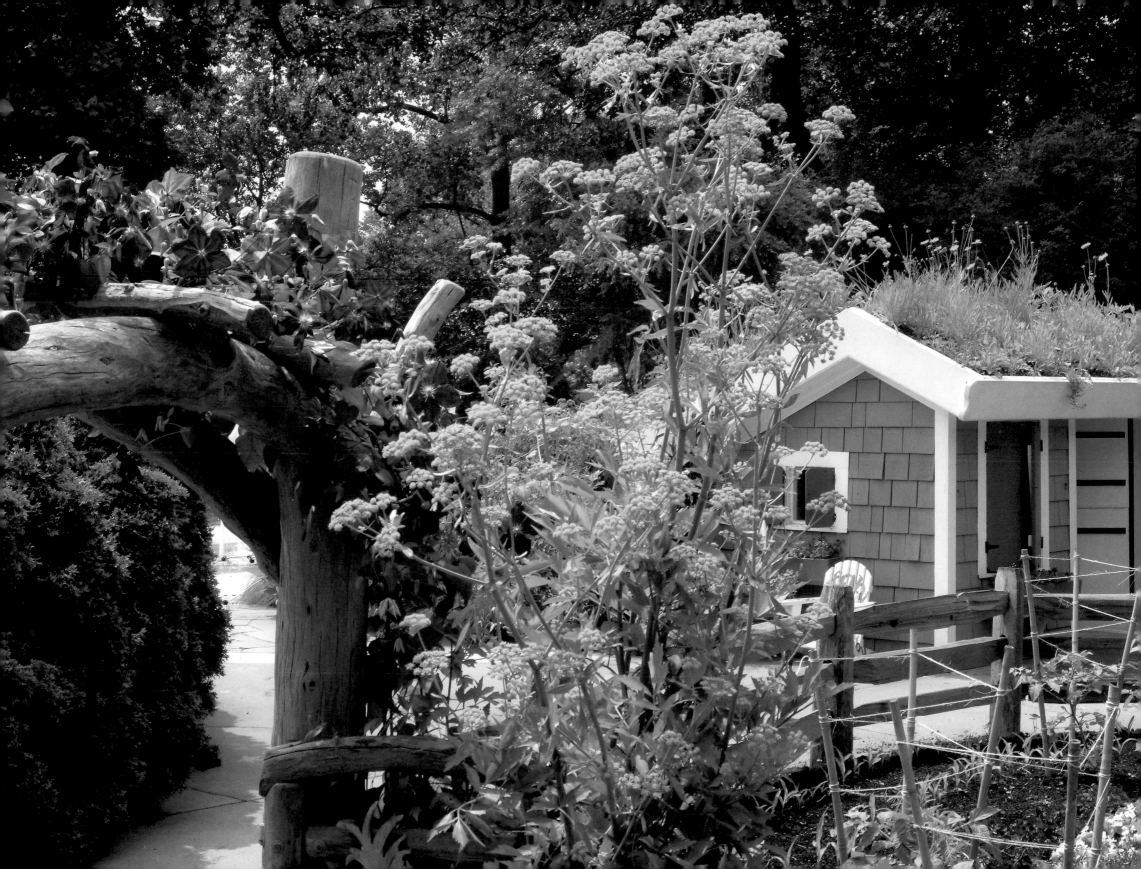

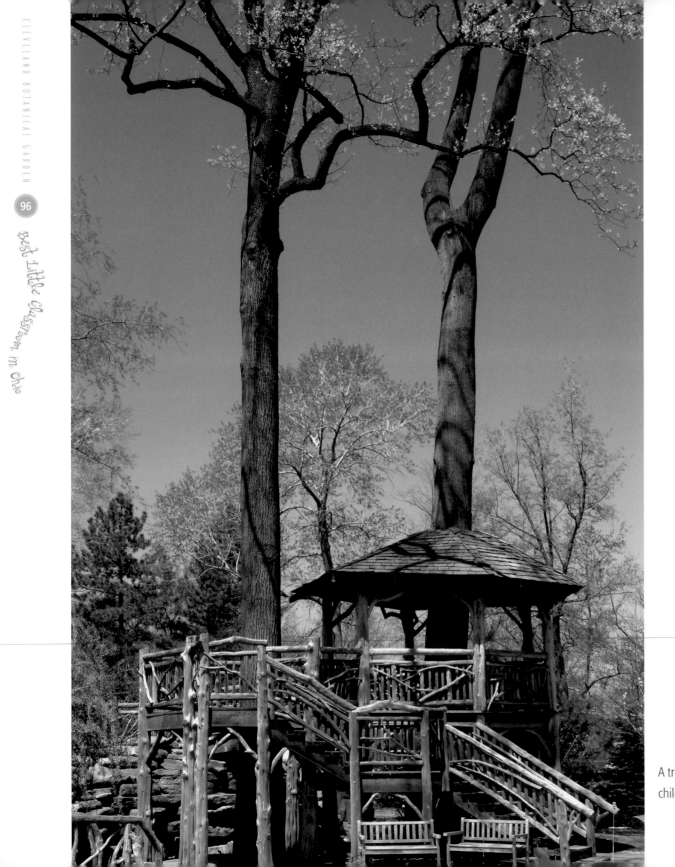

trees to climb, brooks to wade

One section of the garden represents a regional Ohio landscape. A wetland lies beyond the bridge, its presence hinted at by the swamp milkweed and scouring rush growing to the right of the path. The delicate pink flower is hollyhock mallow (*Malva alcea*).

A treehouse topped the wish list of the school children who advised on the garden's design.

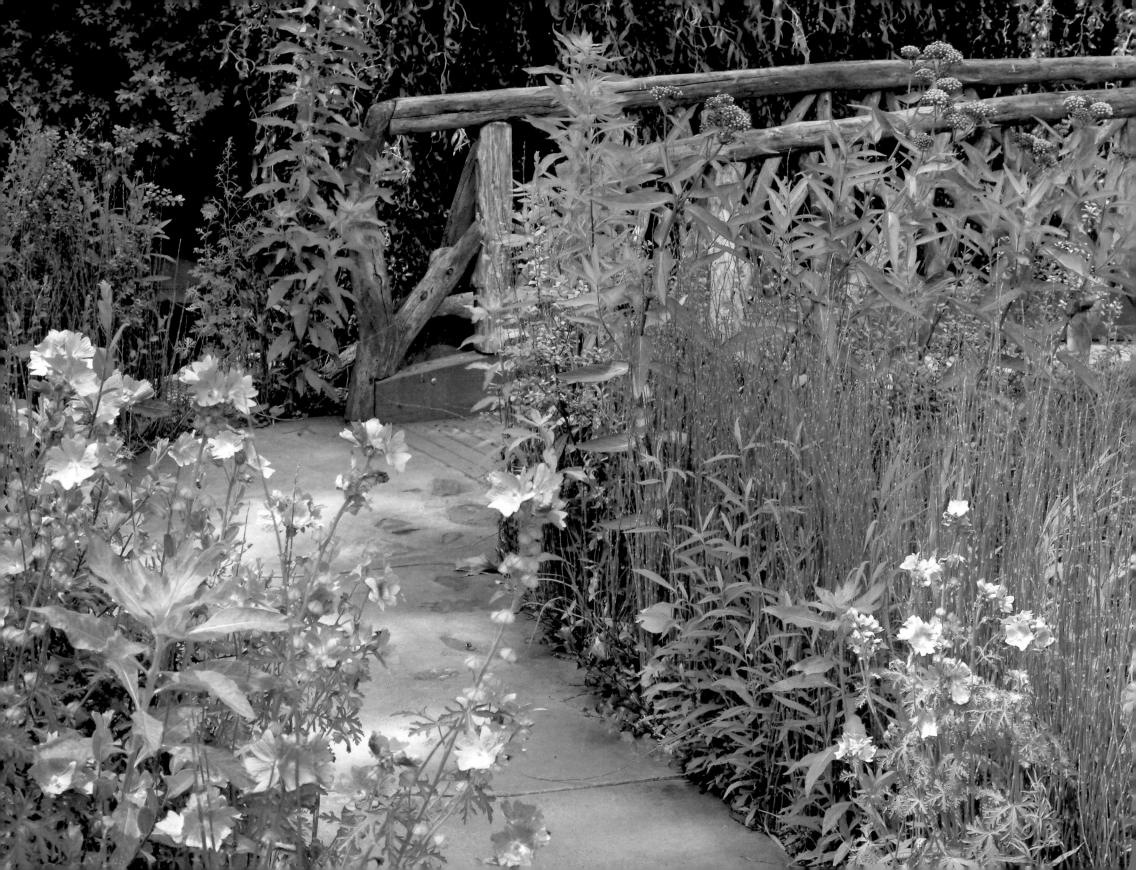

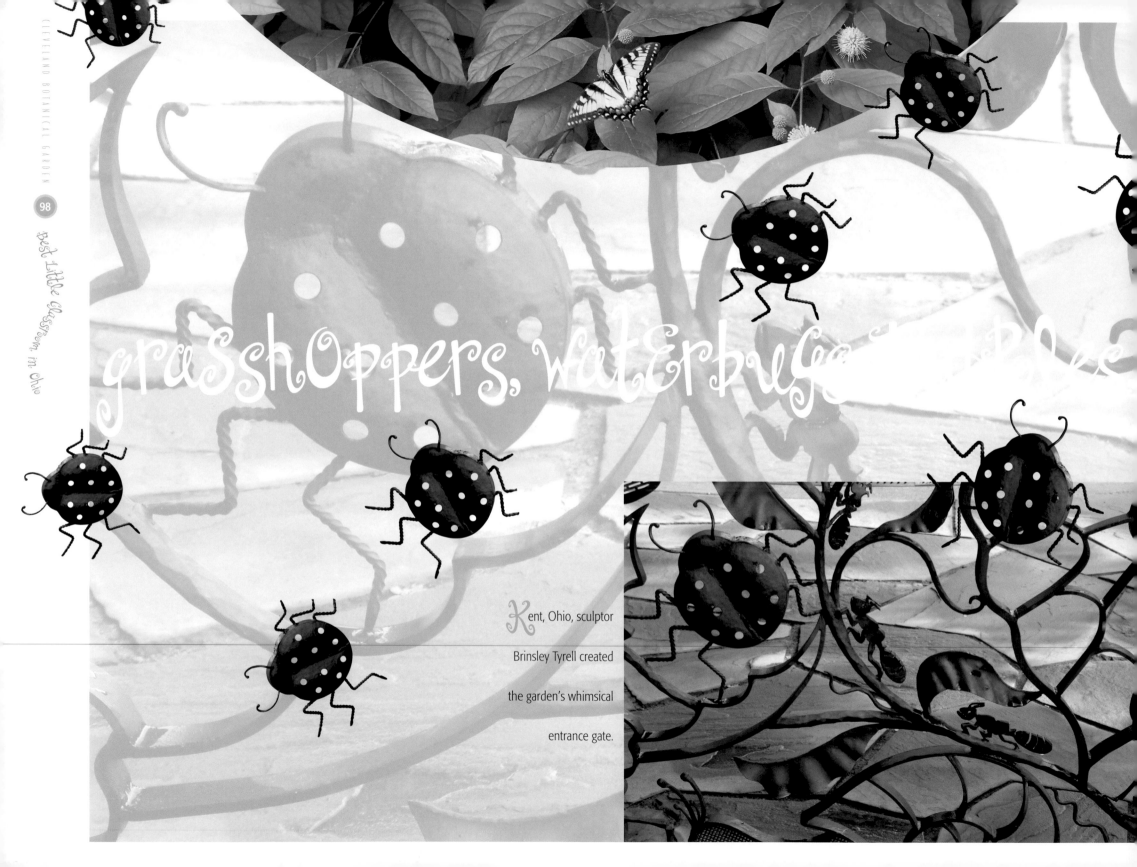

grasshOppers, watErbugs

Kent, Ohio, sculptor

Brinsley Tyrell created

the garden's whimsical

entrance gate.

(Above left) Butterflies love buttonbush (*Cephalanthus occidentalis*). The Eastern tiger swallowtail is no exception.

In the Scrounger's Garden, flowers burst from offbeat containers, demonstrating that plants can be grown successfully in almost any vessel.

PETUNIAS

MILLION BELLS

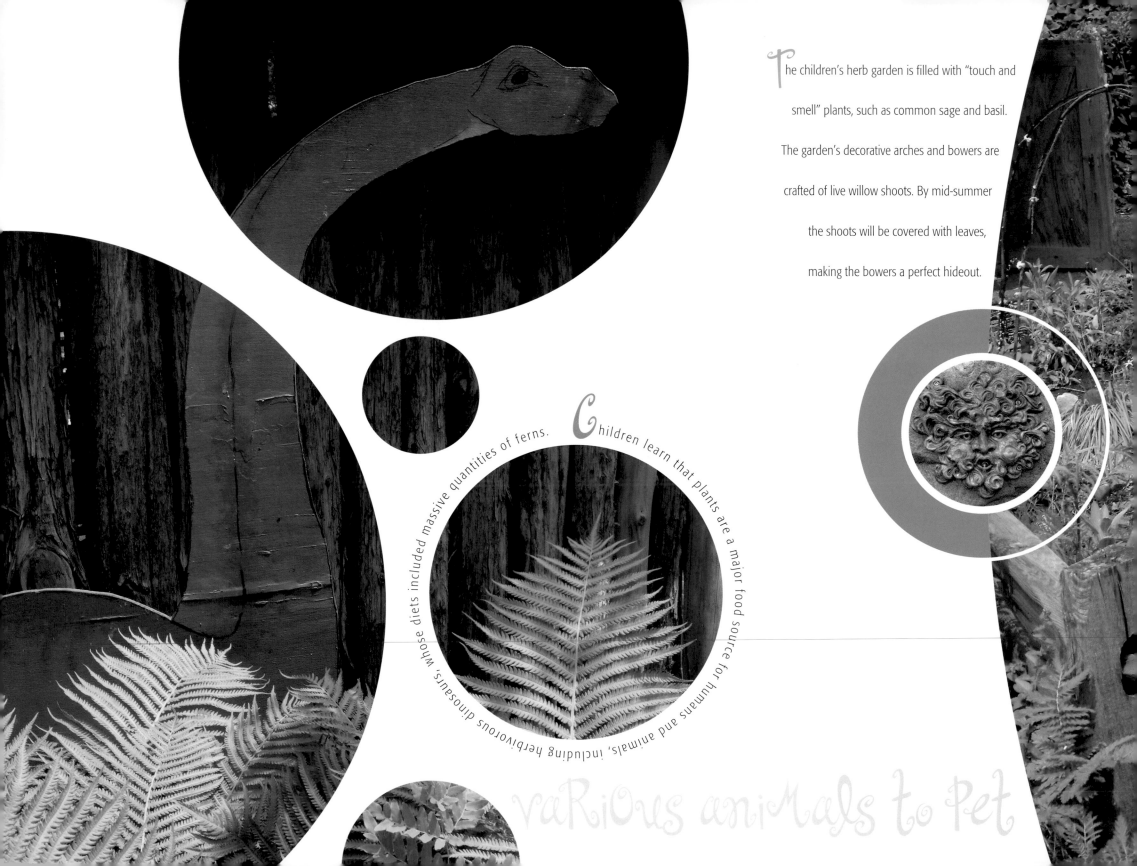

The children's herb garden is filled with "touch and smell" plants, such as common sage and basil. The garden's decorative arches and bowers are crafted of live willow shoots. By mid-summer the shoots will be covered with leaves, making the bowers a perfect hideout.

whose diets included massive quantities of ferns. Children learn that plants are a major food source for humans and animals, including herbivorous dinosaurs,

vaRiOus aniMals to Pet

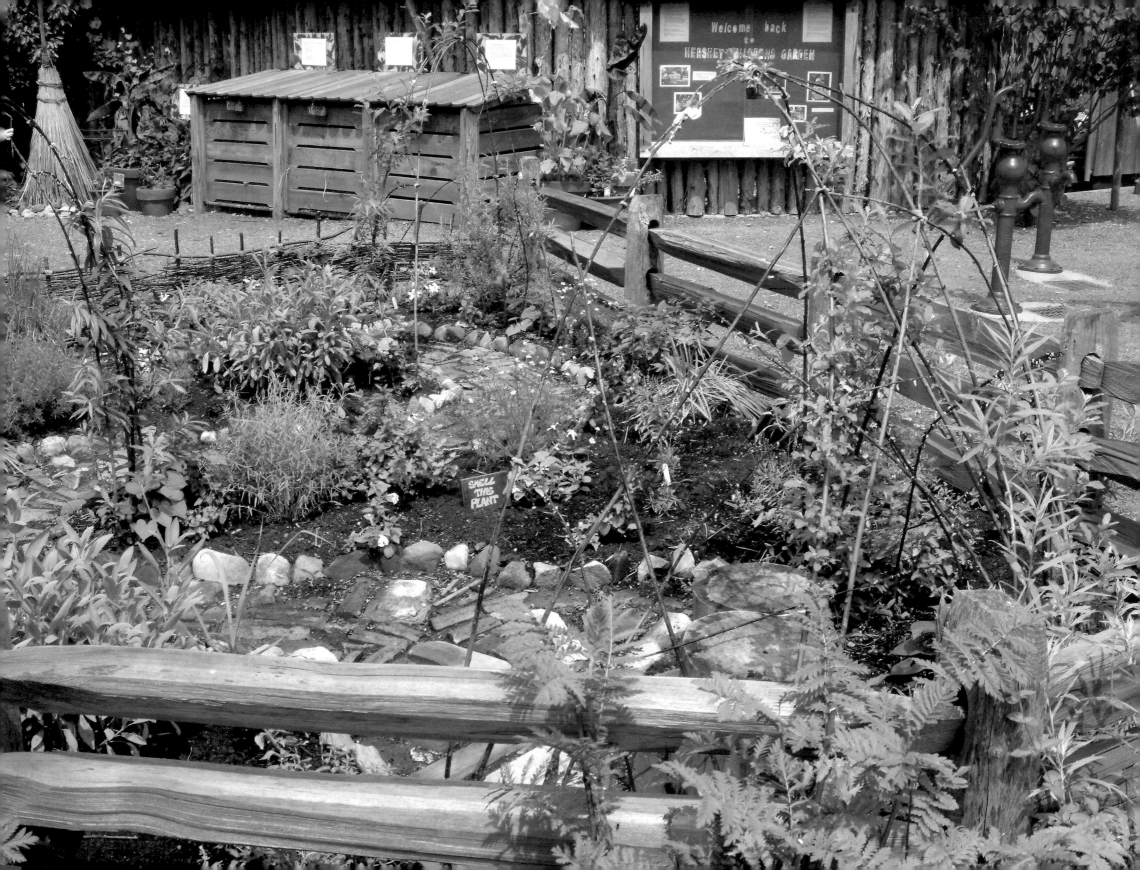

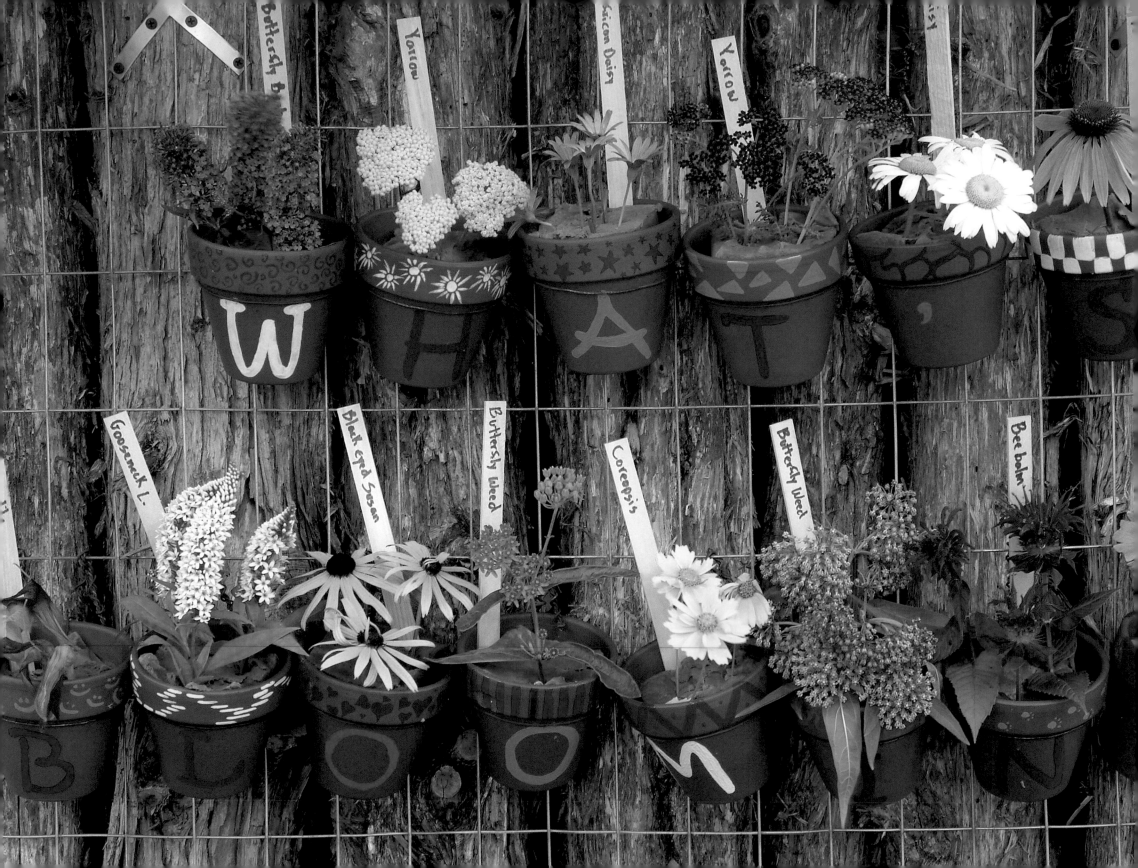

At summer's height, youngsters

can make a game of locating

and learning the name and

appearance of dozens

of blooming flowers.

Special
celebrations mark
all the holiDays.

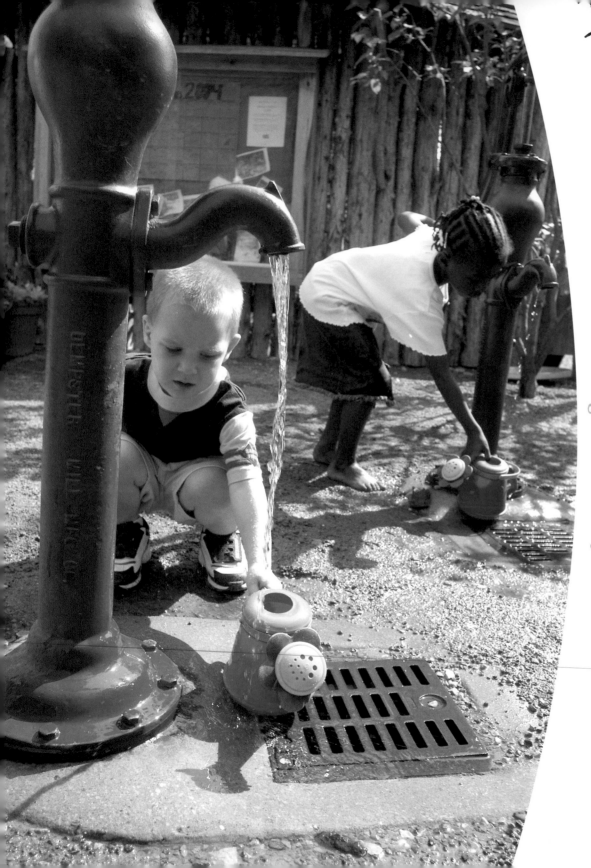

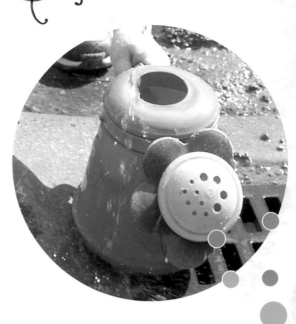

Working pumps attract kids like ants to a picnic. Even the youngest visitors can have a hands-on gardening experience: watering the flowers.

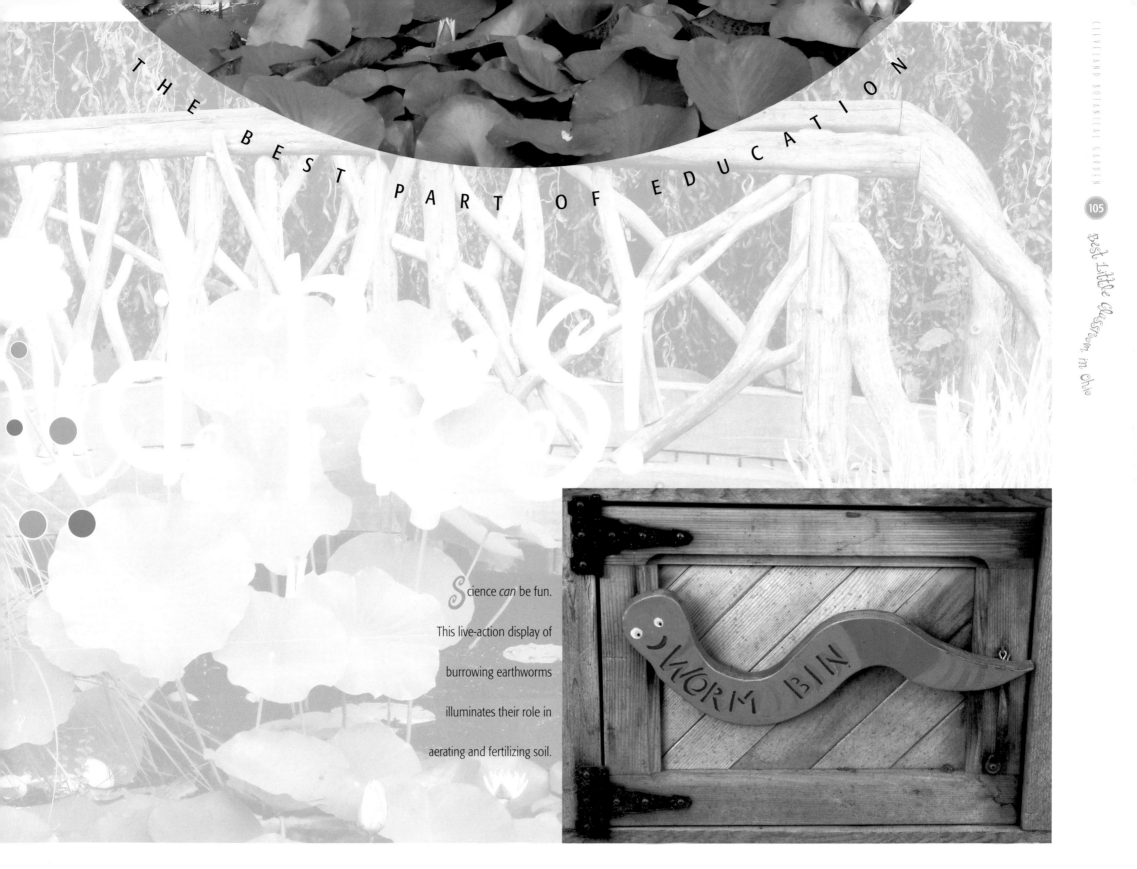

S cience *can* be fun. This live-action display of burrowing earthworms illuminates their role in aerating and fertilizing soil.

WORM BIN

The founders of Cleveland Botanical Garden recognized that their Depression-era city desperately needed a gardening resource center, "where the small homeowner could get suggestions for his tiny plot, and perhaps books of instruction, where children could learn more about the marvels of growing things, and become acquainted with plants that otherwise would never come to their knowledge," in the words of a 1930 news account. How their idea has blossomed! To introduce today's avid gardeners to new or unusual plants, every two years Cleveland Botanical Garden mounts North America's largest outdoor flower show. Featured theme gardens, which remain on display for the following 24 months, illustrate how to turn sunny, shady, hilly or flat expanses into dream landscapes. In between flower shows, an 18,000-volume reference library and a steady stream of horticultural classes, lectures and workshops keep practical information and new ideas flowing.

Ideasource

PLANT
A SEED
CELEBRATE
LIFE

The aesthetics and techniques

of flower arranging have been a

programming anchor since the

Garden's inception in 1930.

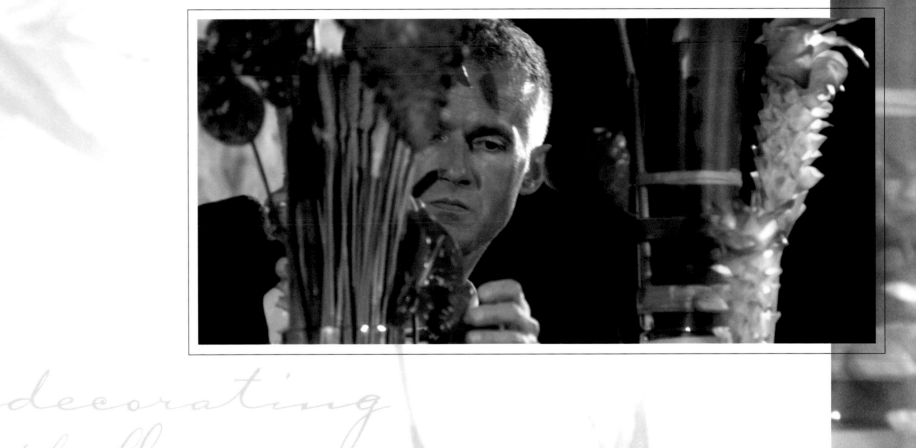

*decorating
with flowers*

Seven hundred and fifty individually strung bird-of-paradise flowers waft magically above visitors' heads
in the ellipse. Such decorations are changed frequently, lending seasonal charm to the lobby area.

*E*xtreme Arranging, a weekend of special classes and workshops, upended conventional ideas about which color schemes and materials make for a striking flower arrangement.

The acclaimed floral designers who created Extreme Arranging masterpieces joined a steady stream of authors, horticulturists, arborists, landscapers and nursery growers brought in to share their expertise with Garden members and the public.

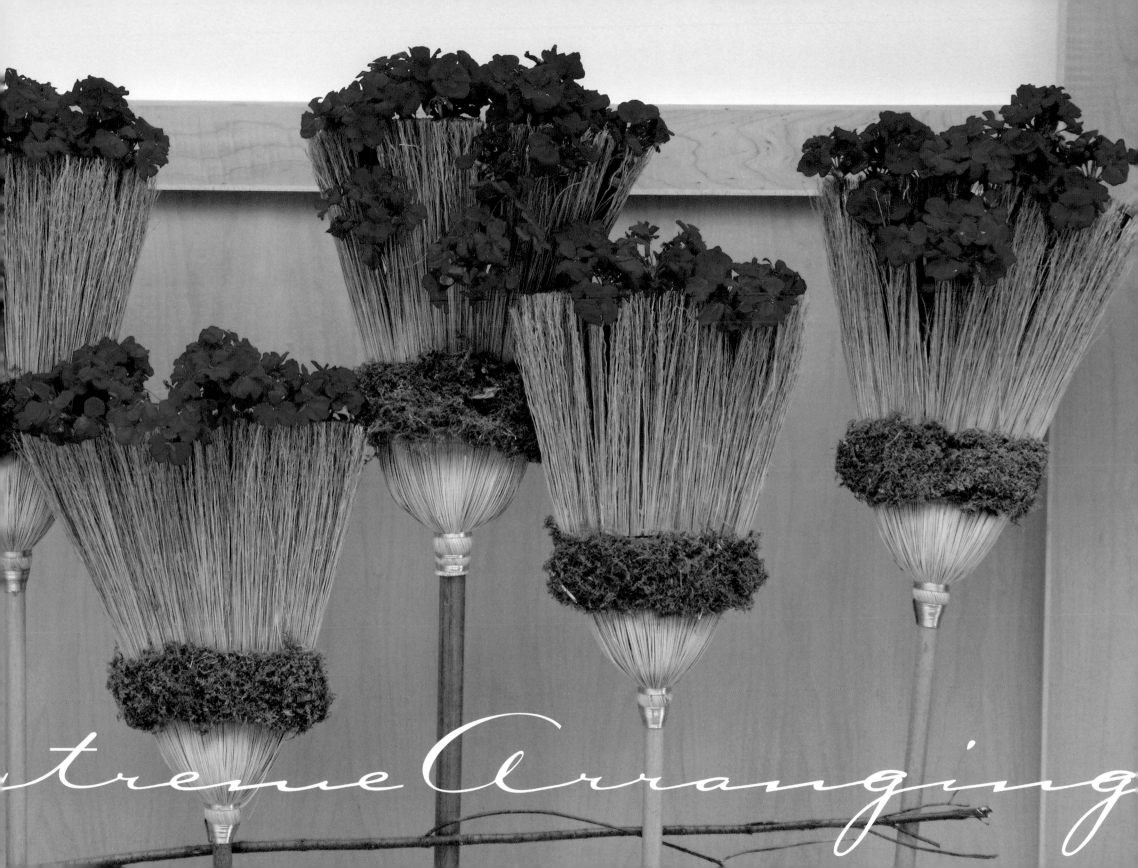

xtreme Arranging

Chili Pepper Festival

Special programs at the Garden deepen visitors' enjoyment and knowledge of plants.
A summer festival, for example, might celebrate the world's astounding variety
of chili peppers grown by heat-loving cultures from Korea to Mexico.

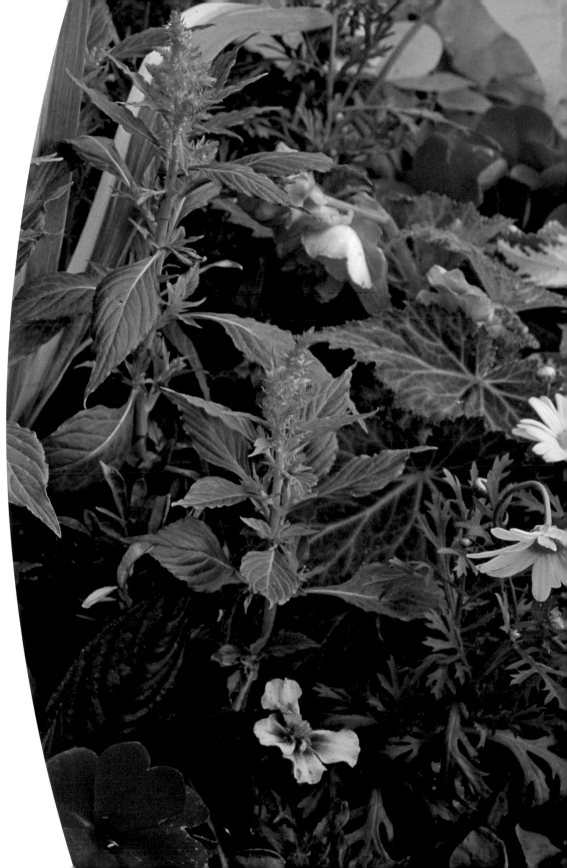

The Garden's outdoor terrace is planted anew each spring with the latest trendy annuals. In this container garden, the brilliant orange spires of the familiar cockscomb (*Celosia argentea* var. *cristata* "Apricot Brandy") make it a standout. The round, multicolored leaves of the zonal geranium (*Pelargonium* x *hortorum*) add interest.

artistry with annuals

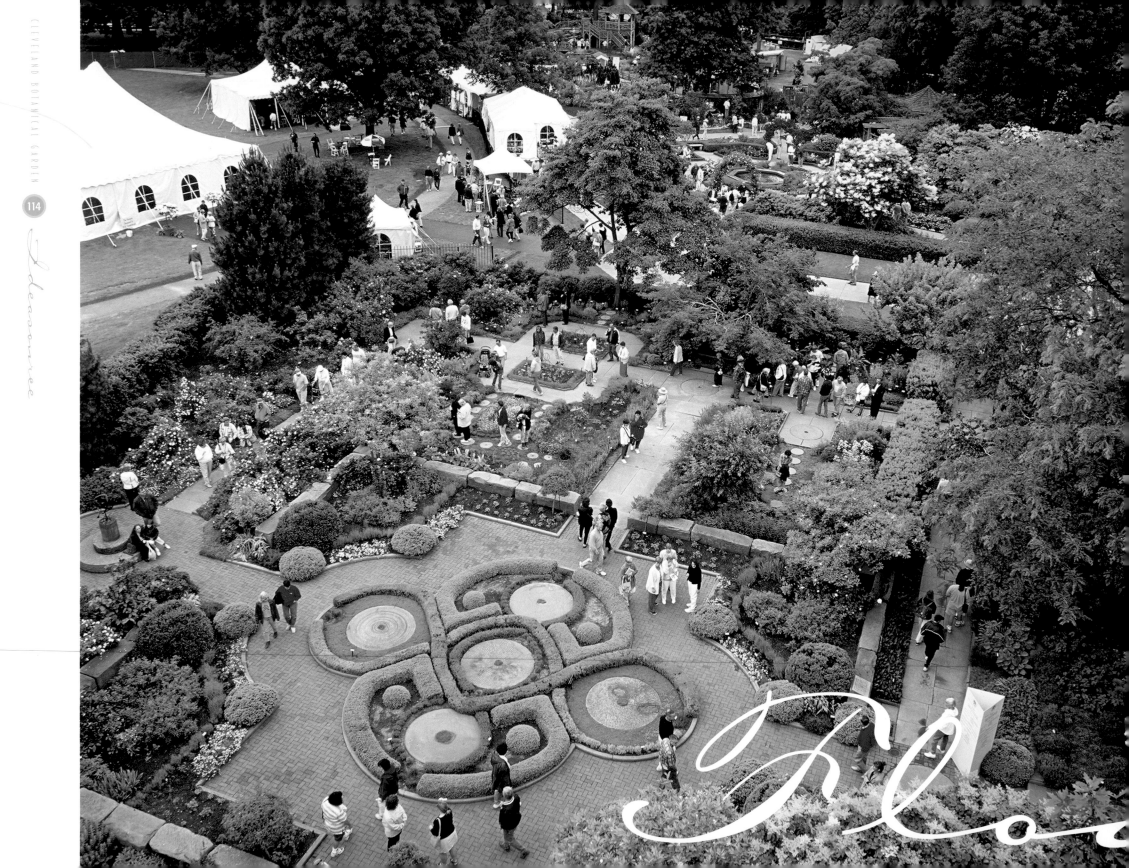

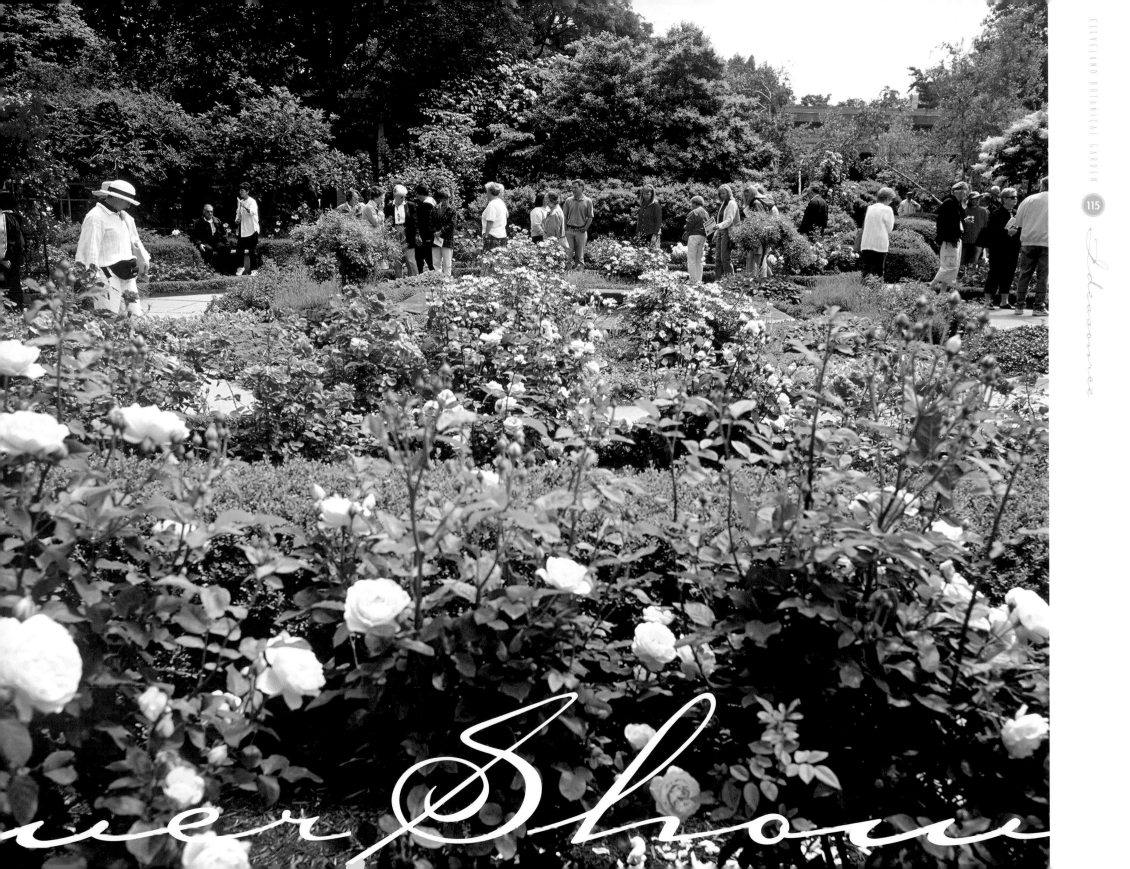

wer Show

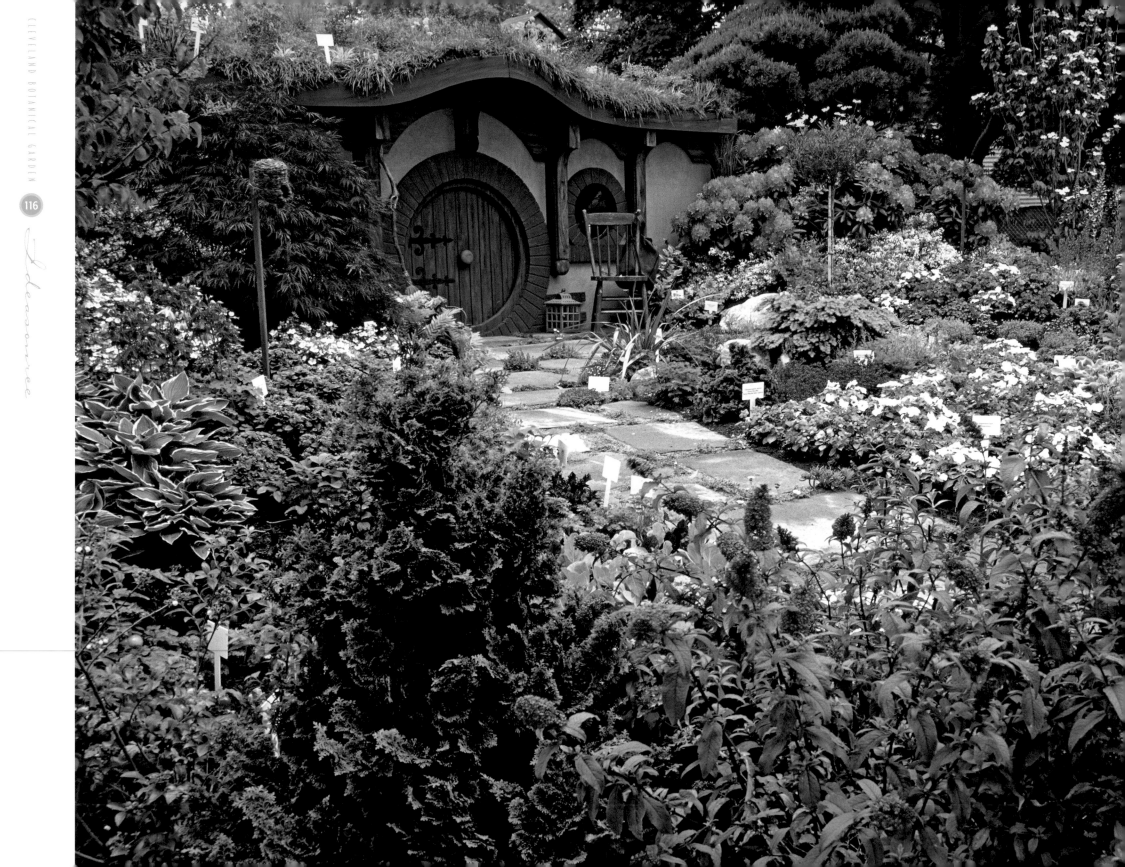

*C*leveland Botanical Garden Flower Show is one of only eight such competitions in the country to be certified by the Garden Club of America and National Garden Clubs, Inc., as a "major show."

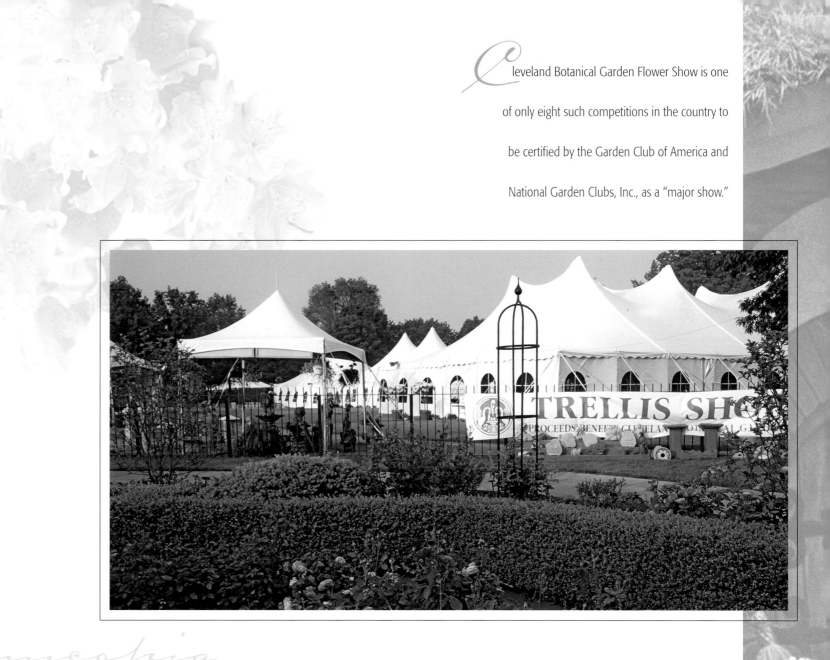

cornucopia of information

The biannual event typically features more than 900 entries in the competitive divisions of horticultural specimens, floral arrangements, botanical jewelry and photography; a cornucopia of vendors; and lavish living gardens designed by outstanding area landscaping firms. Barnes Nursery Inc. of Huron, Ohio, conceived the fanciful Hobbit Garden at left for the second annual outdoor Flower Show.

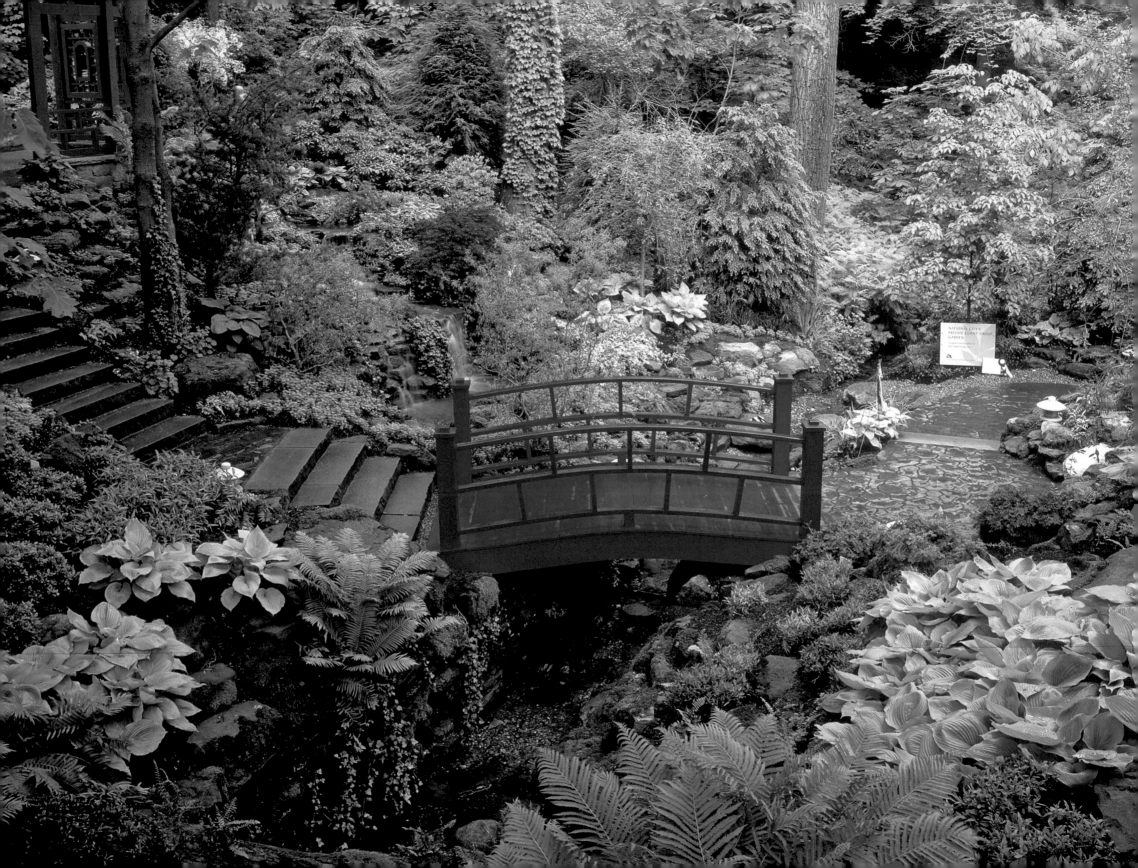

Theme Gardens

With its red bridge and teahouse, a theme garden designed by The Pattie Group of Novelty, Ohio, reflects a Japanese influence. Canadian hemlock (*Tsuga canadensis*) and a variety of flowering rhododendrons and Japanese maples frame a green tapestry of hosta and ferns suitable for the shady site.

A hanging garden of stepped stones, purple-leaved, weeping Japanese maple and *Rhododendron* "Roseum Elegans" frames a water feature designed by DeWeese Landscaping of Chardon, Ohio.

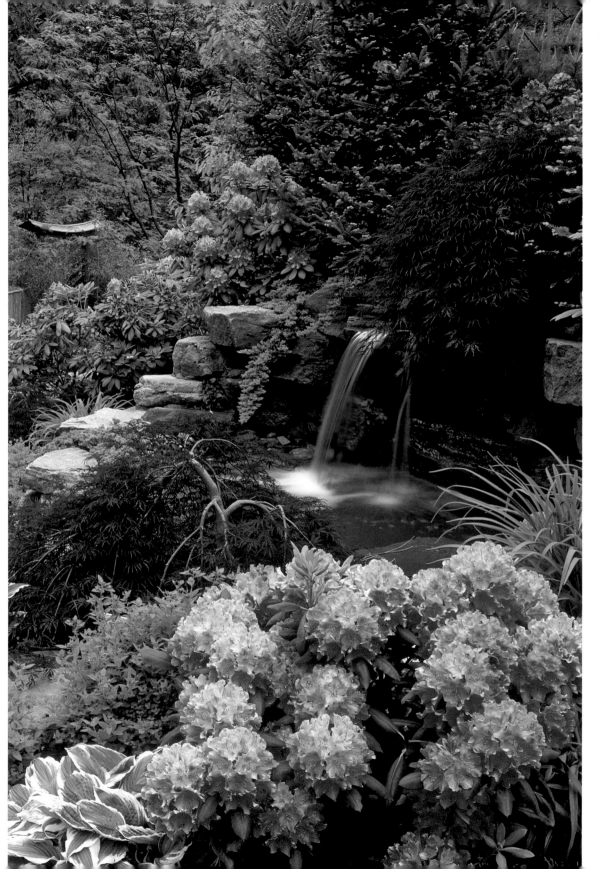

Physiological research has now proven something people have long suspected: Time spent in a garden setting makes us feel good. Cleveland

Botanical Garden has capitalized on the power of plants to soothe everyday stresses. Benches abound throughout the grounds, inviting

visitors to linger. Serene and trickling water features encourage contemplation. Visitors with physical challenges feel especially at home in

The Elizabeth and Nona Evans Restorative Garden, which has been designed particularly for their enjoyment. Its beauty can be experienced

via multiple senses: hearing, smell and touch, as well as sight. The Garden also promotes wellness through a host of activities ranging from

horticultural therapy classes to instruction in yoga, qigong and T'ai Chi.

(h)ealing

presence

in

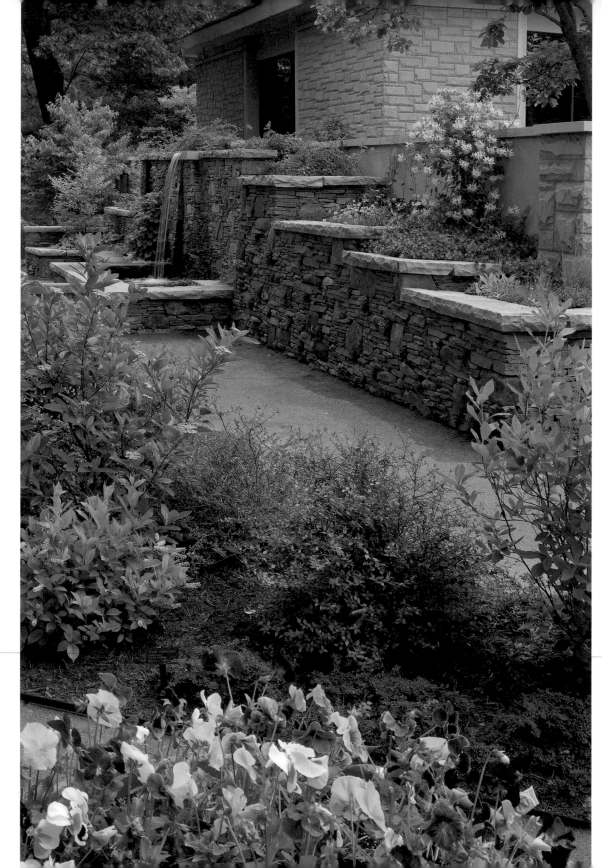

Sensitive touches assure the accessibility of The Elizabeth and Nona Evans Restorative Garden. Paths are wide and gently sloping, and the emerald lawn in the contemplative area has been grown from a turf grass dense enough to keep a wheelchair from sinking. A water feature can be heard or touched by those who may not be able to see it.

r e s t o

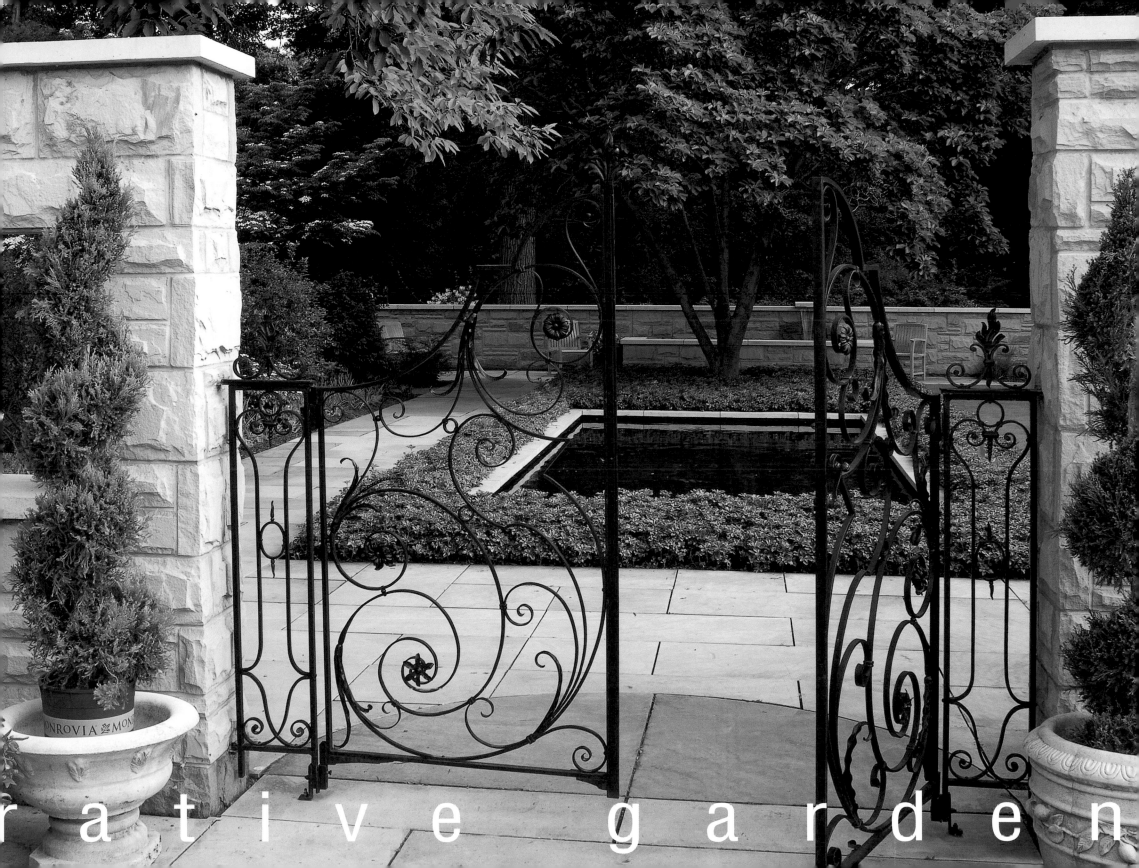

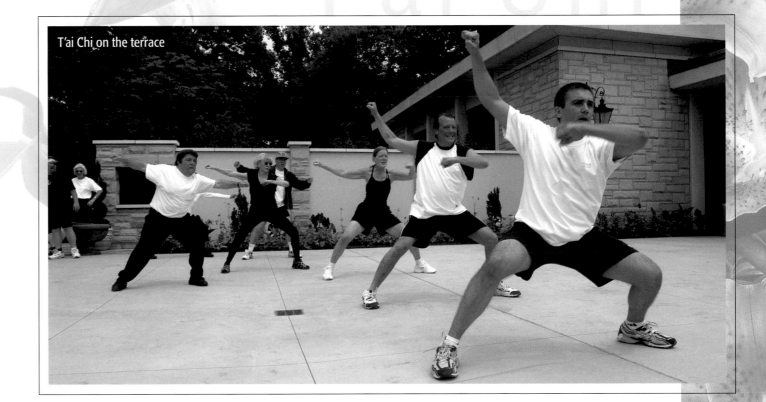

T'ai Chi on the terrace

sensual smorgasbord

Flowers, trees and shrubs in the Restorative Garden have heady fragrances or interesting textures or attention-grabbing bright colors. Brilliant pink hybrid oriental lilies perfume the air, while the handsome, flaking bark of the *Stewartia koreana* cries out to be rubbed.

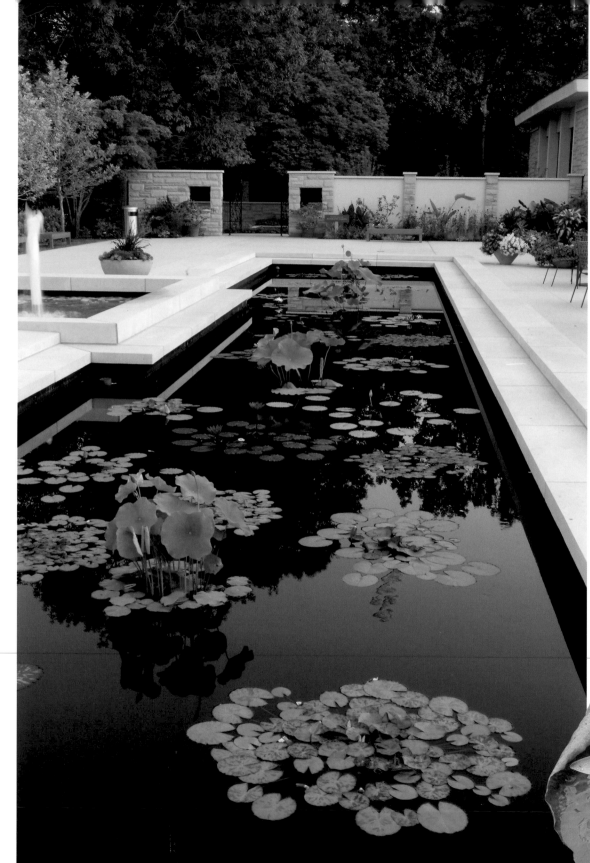

adjoining the Restorative Garden is an outdoor terrace featuring the elegant, 74-foot-long William E. Conway Family Pool. In the summer the terrace is a popular spot for rejuvenating lunches under umbrella-covered tables.

Floating serenely on the inky waters of the reflecting pool, the Victoria water lily (*Victoria amazonica*) is one of the wonders of the plant world. In equatorial regions, its leaves can grow to be seven feet in diameter. Its spines ward off aquatic herbivores.

t

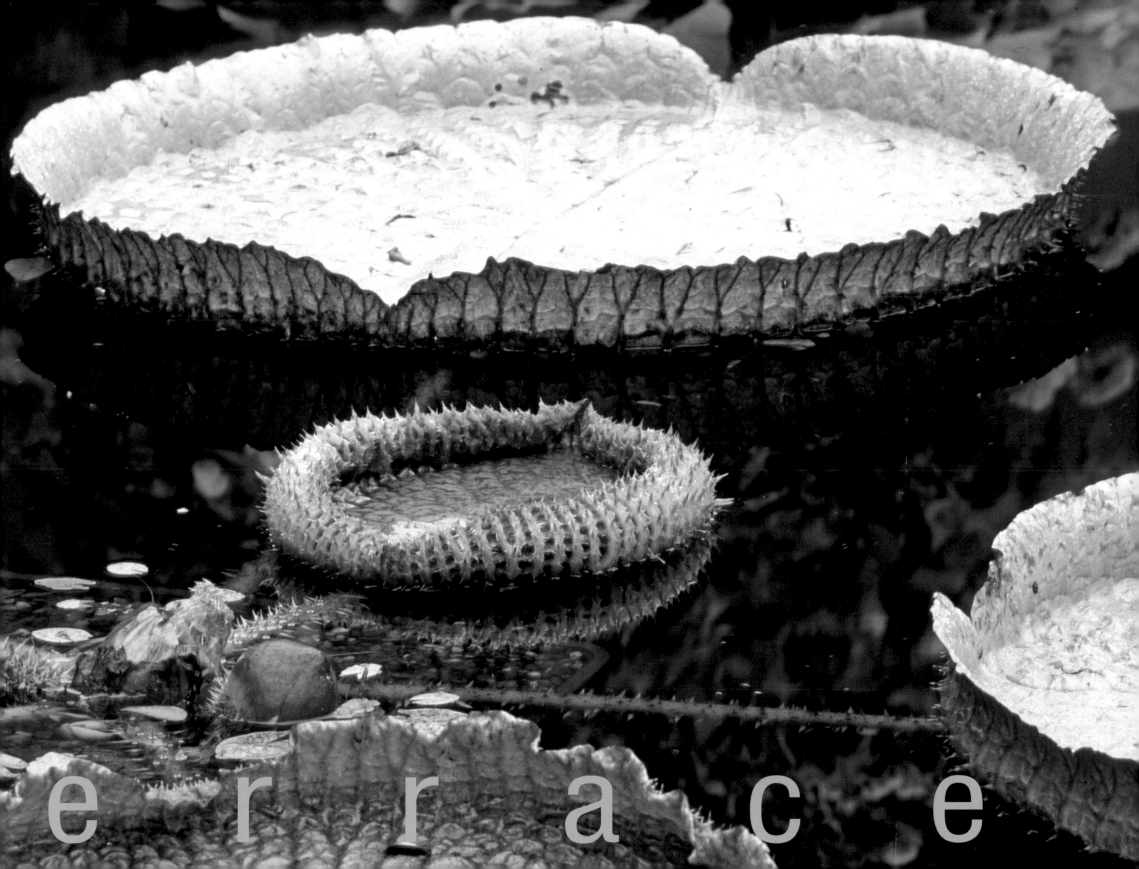

Ludwigia sedoides may be a common pond plant in Central and South America, but it is of uncommon beauty. Visitors ask more questions about the "mosaic" plant than any other species growing in the reflecting pool.

the sacred lotus (*Nelumbo nucifera*) has

been cultivated for more than a millennium.

It is a symbol of purity and perfection in

Asian cultures, which use its blossoms

as an aid to meditation and as a motif

in carvings and paintings. Surprisingly,

this exotic plant is hardy in

Ohio ponds.

Adopt a vacant lot on a busy urban street. Dig beds in which to plant vegetables, herbs and flowers. Bring in kids from around the city and show them how to grow tomatoes and basil and sunflowers, working side by side with adults skilled in the craft of gardening and passionate about horticultural education. What do you produce? Flourishing gardens, and an even more important harvest: young people who have an appreciation for all living things, a sense of purpose and the ability to make a difference in their communities. As key venues for Cleveland Botanical Garden's urban education program, The Learning Garden and Esperanza Garden are seedbeds of youthful leadership. They also serve their central-city neighborhoods as inspirational showplaces and safe, green havens.

good

neig

neighbor

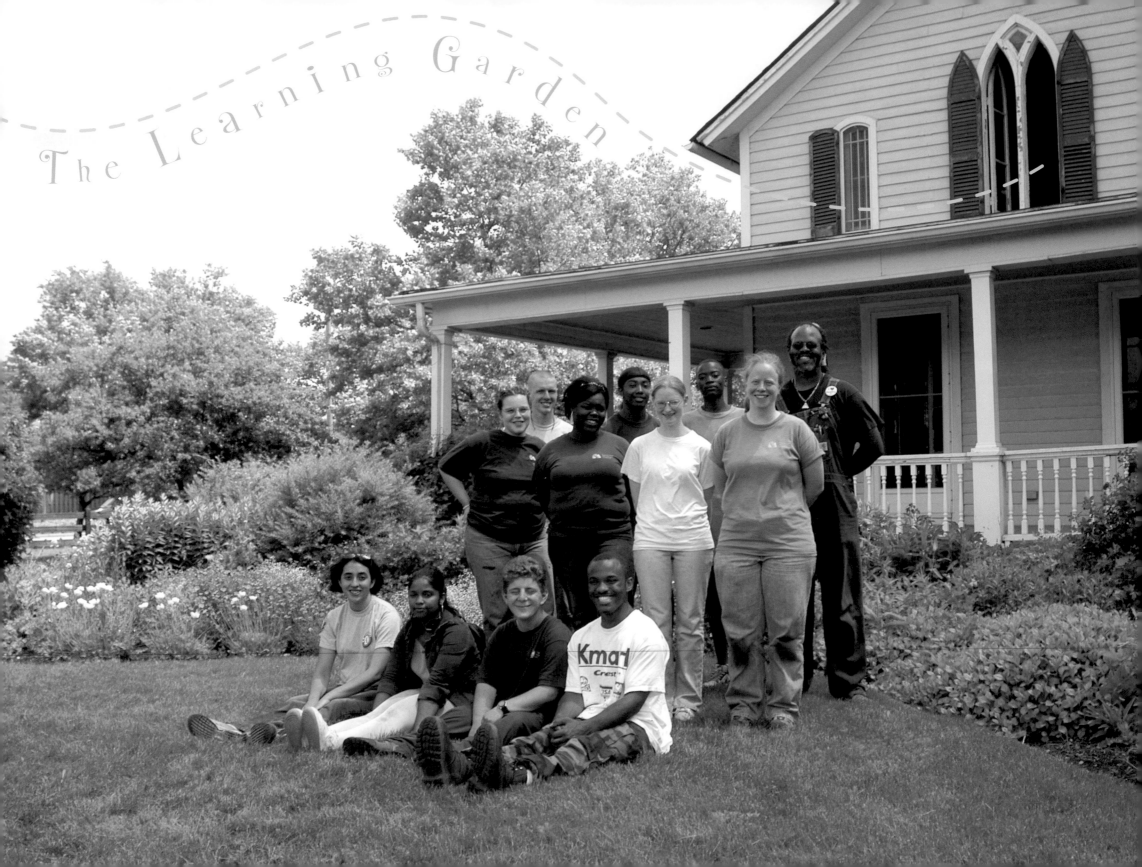

*g*reen Corps members spend summers at The

Learning Garden in midtown Cleveland, tending

vegetables and flowers. Program manager

Maurice Small (in the bib overalls) teaches the

teenagers a host of new skills, including the

ability to identify native Ohio plants. Mountain

mint *(Pycnanthemum muticum)*, whose flower

head is pictured above, is easy to remember; it

emits a menthol fragrance when crushed. "Wait

until you see our hollyhocks," an enthusiastic

Green Corps member bragged to a visitor to

program headquarters in the Little Yellow House.

S e E d B e D s

of YOUTHFUL LEADERSHIP

Sunflowers add their unique radiance to an educational array of grandmother's cottage perennials at The Learning Garden. An exuberantly painted chicken coop serves as a shelter for a squadron of cackling hens and as an expression of Green Corps pride.

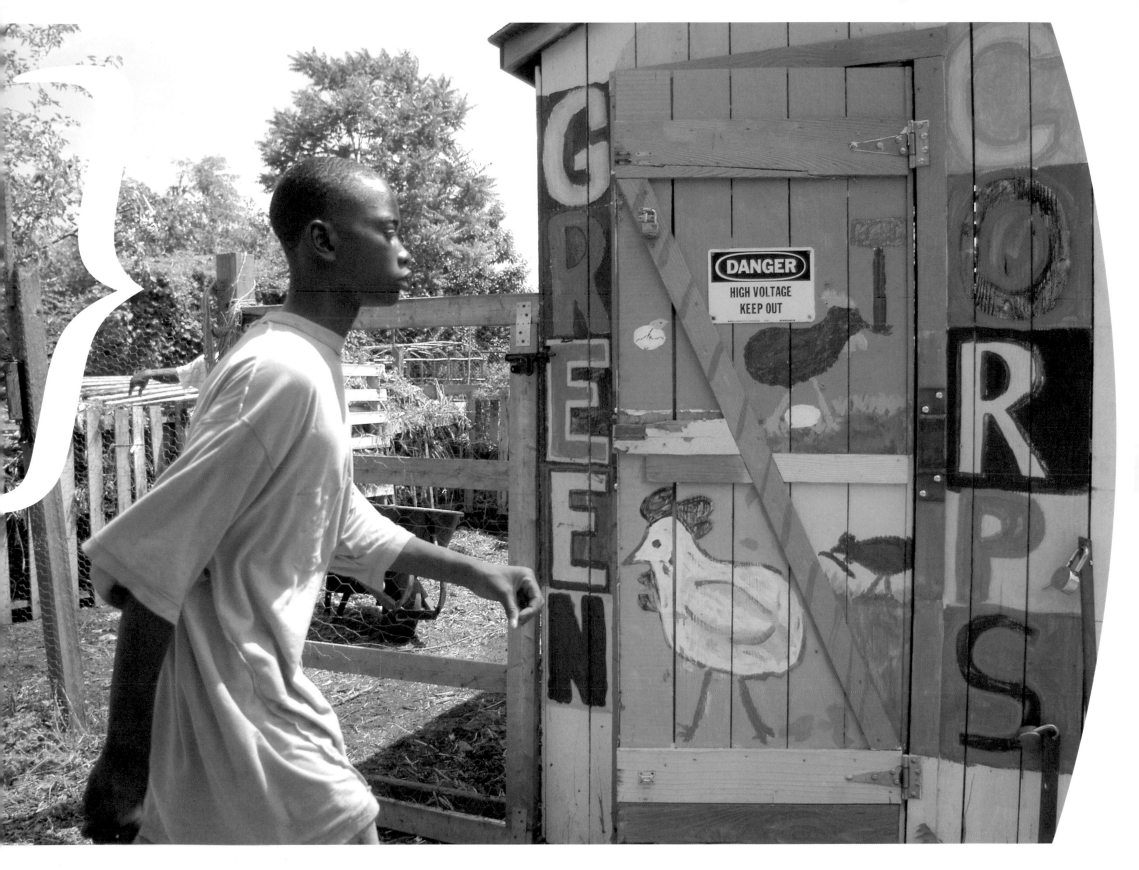

136

esperanza garden

ripe
from downtown

home to a second unit of the Green Corps, Esperanza Garden is fittingly named. The pocket

garden on West 25th Street south of Cleveland's West Side Market spreads a message of hope

that even the patchiest of soil can be made productive.

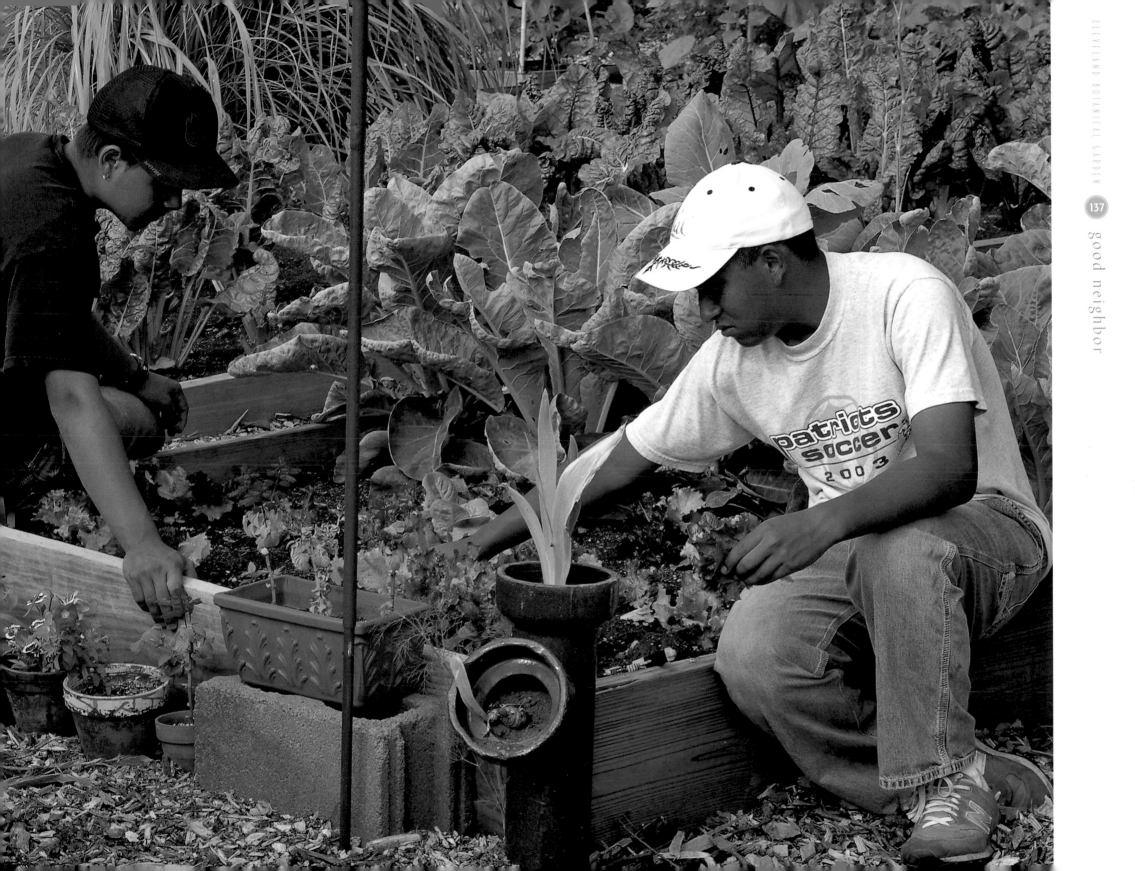

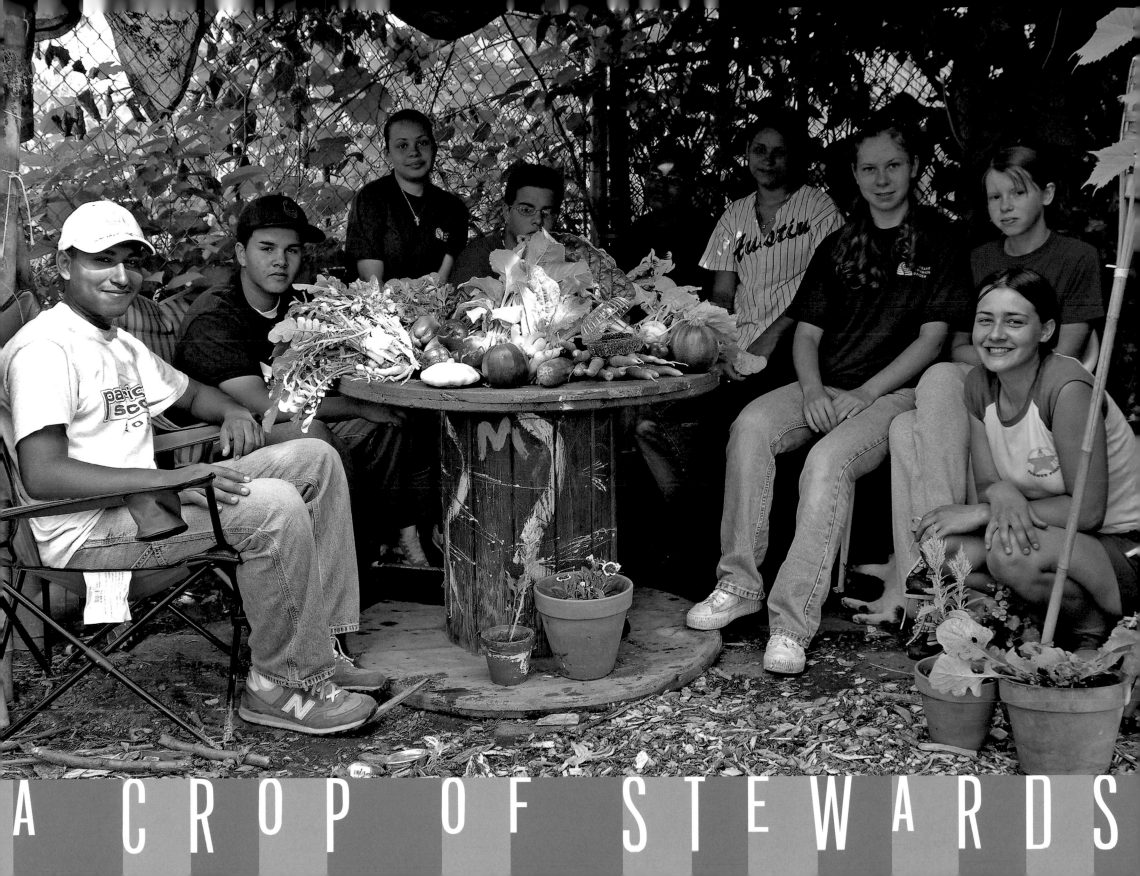

A CROP OF STEWARDS

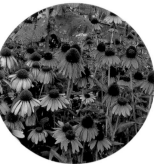

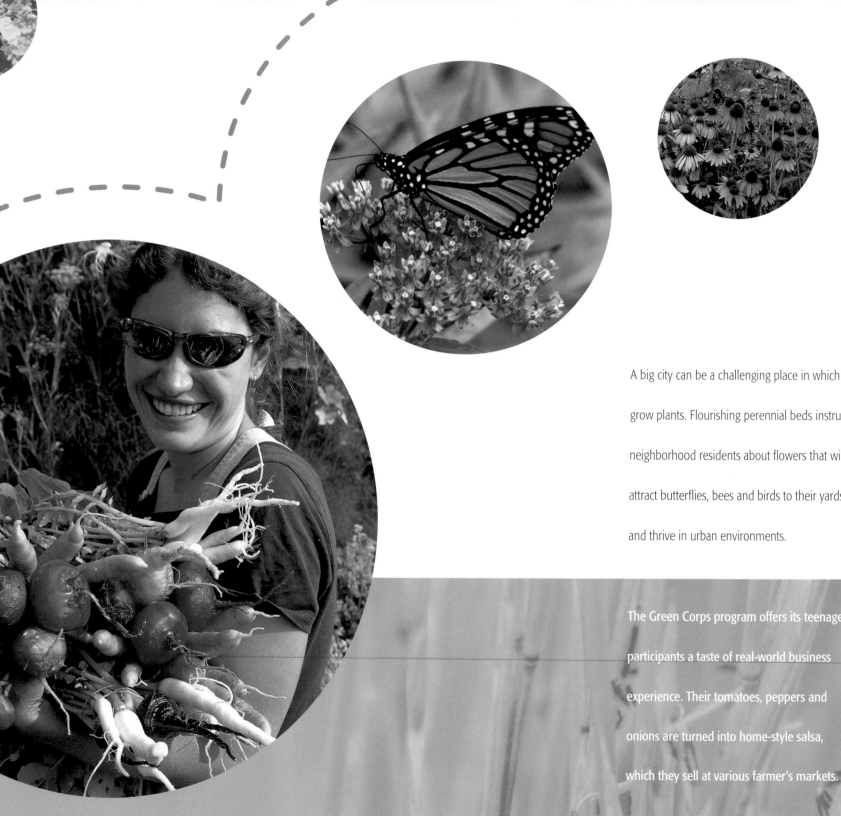

A big city can be a challenging place in which to grow plants. Flourishing perennial beds instruct neighborhood residents about flowers that will attract butterflies, bees and birds to their yards and thrive in urban environments.

The Green Corps program offers its teenaged participants a taste of real-world business experience. Their tomatoes, peppers and onions are turned into home-style salsa, which they sell at various farmer's markets.

Paradeisos was the ancient Greek word for garden, and the connotation of "paradise" as a region of surpassing beauty and delight still

resonates today. But where can you find such perfection on earth? Cleveland Botanical Garden's historic gardens come close. The Western

Reserve Herb Society Herb Garden, Mary Ann Sears Swetland Rose Garden, Woodland Garden and Gan Ryuu Tei Japanese Garden are a

symphony of color, shape and texture—an ode to the joy-inducing powers of plants. Although timeless in design,

each rewards regular visits with ever-changing wonders of blossom, fruit and fragrance. Around each turn

in the gardens' paths another glimpse of paradise awaits, and in these ethereal surroundings the

world-weary regain a sense of tranquility and contentment.

WESTERN RESERVE HERB SOCIETY HERB GARDEN

GAN RYUU TEI JAPANESE GARDEN

MARY ANN SEARS SWETLAND ROSE GARDEN

WOODLAND GARDEN

deisos

embers of the Western Reserve Herb Society, a unit of the Herb Society of America, have maintained a

show and learning garden in University Circle since the mid-1940s. The present herb garden dates to 1969.

A marvel of picturesque design, seasonal color and comprehensiveness—more than 300 herb species, including

ornamental onion *(Allium)*, pictured here, are grouped into seven specialty quadrants according to their traditional

uses—the garden features one of the world's largest English knots. Its decorative millstones are six feet wide.

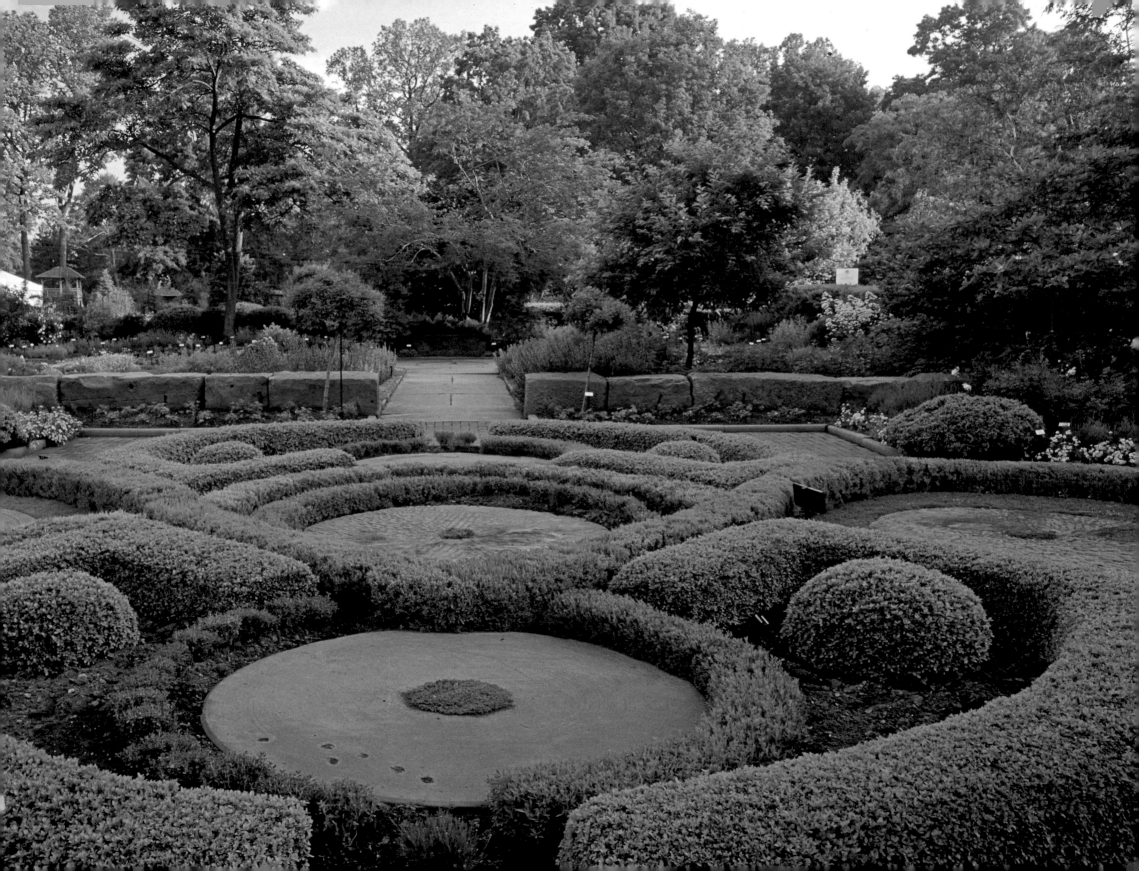

To the south of the knot lies the trial and cutting garden, pictured here in summer and fall. Yarrows, salvias, thymes, lavenders, rosemaries and artemisias are clipped, dried and prepared to be sold as wreaths, arrangements and culinary items at the herb society's annual fair.

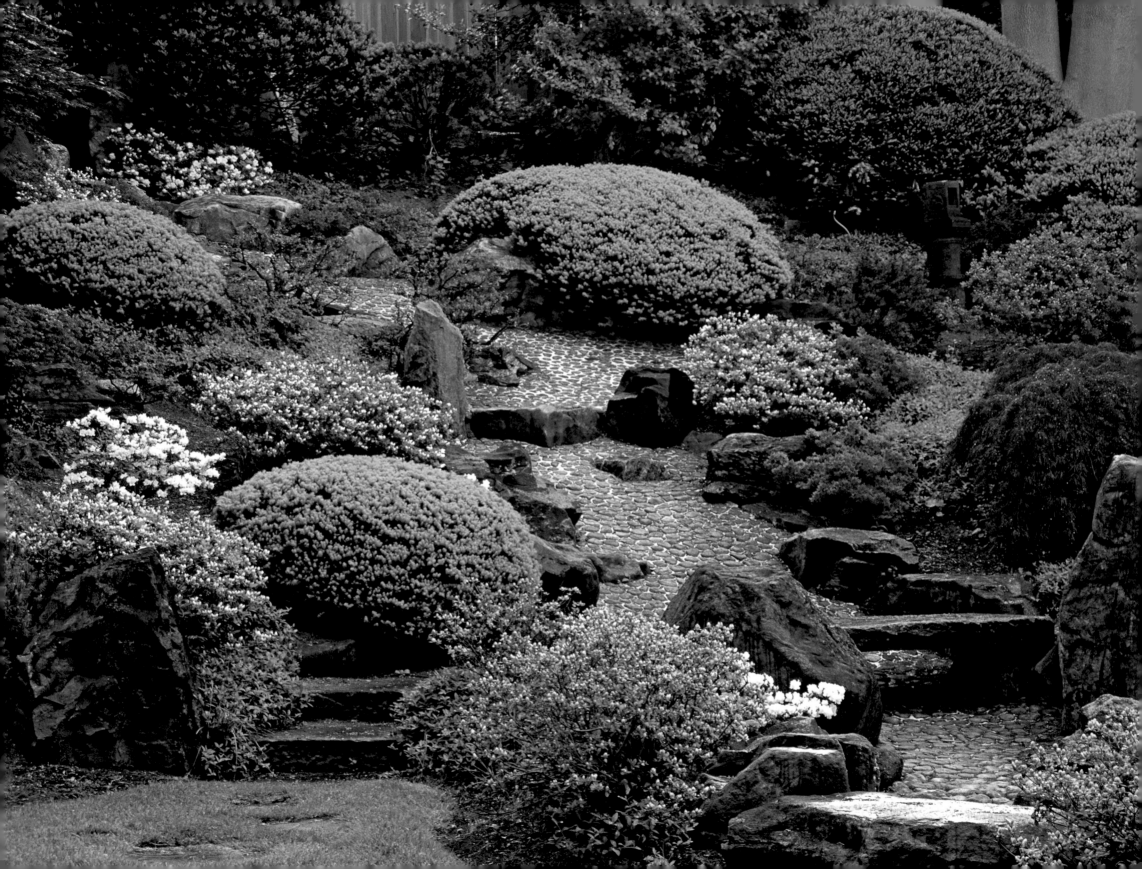

Cross a bridge, stroll through a tea garden and pause beneath a wisteria-covered trellis. You've entered the magical realm of Gan Ryuu Tei (Rock Stream Garden), a Japanese mountainscape rendered in picture-perfect miniature. The "dry" cascade has been achieved with a classic composition of rocks, clipped evergreen azaleas and weathered beach stones.

Winter berries of *Cotoneaster*

JAPANESE GARDEN

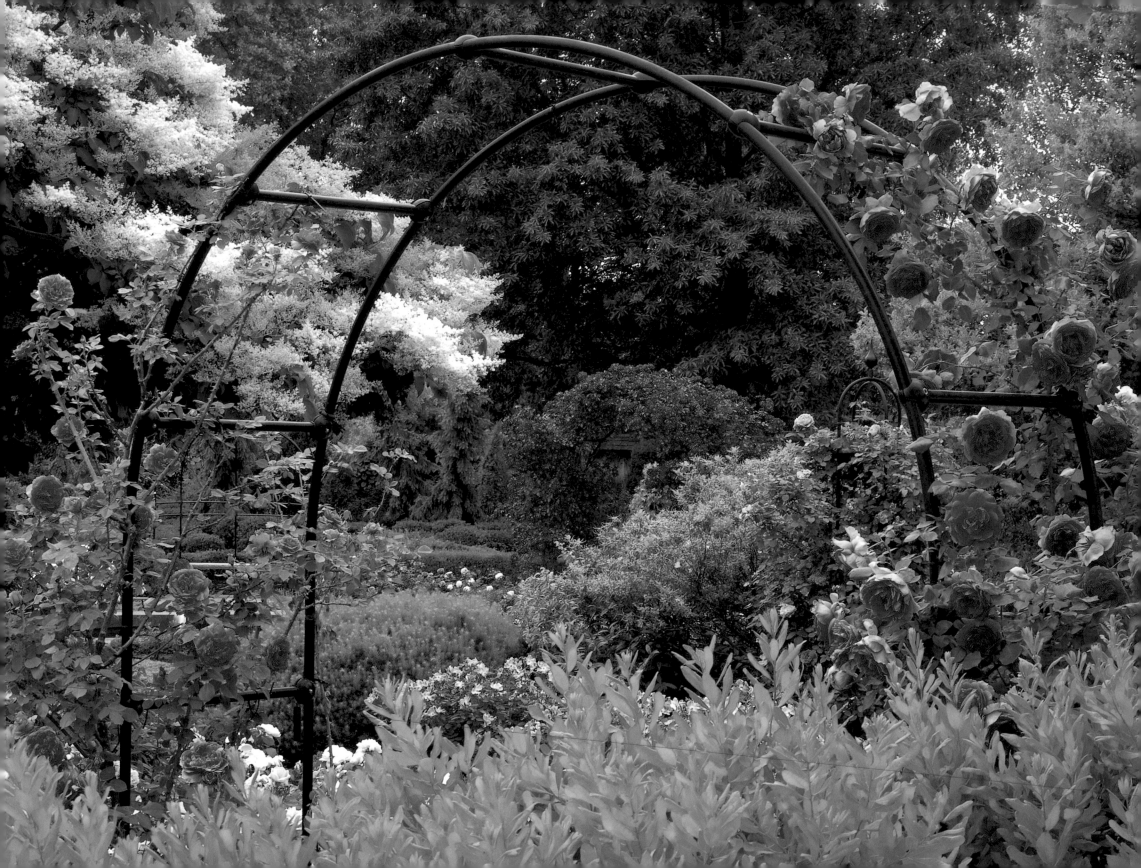

Floribundance:
The Mary Ann Sears Swetland Rose Garden
showcases hybrids chosen for their pronounced
ornamental attributes. That's *Rosa* 'Parade' climbing the near trellis
(and in the close-up on this page), *Rosa* 'Dortmund" on the far trellis
and *Rosa* 'Nearly Wild' in lower center. When in bloom, the Japanese tree lilac
(Syringa reticulata) can almost upstage its candy-colored companions.

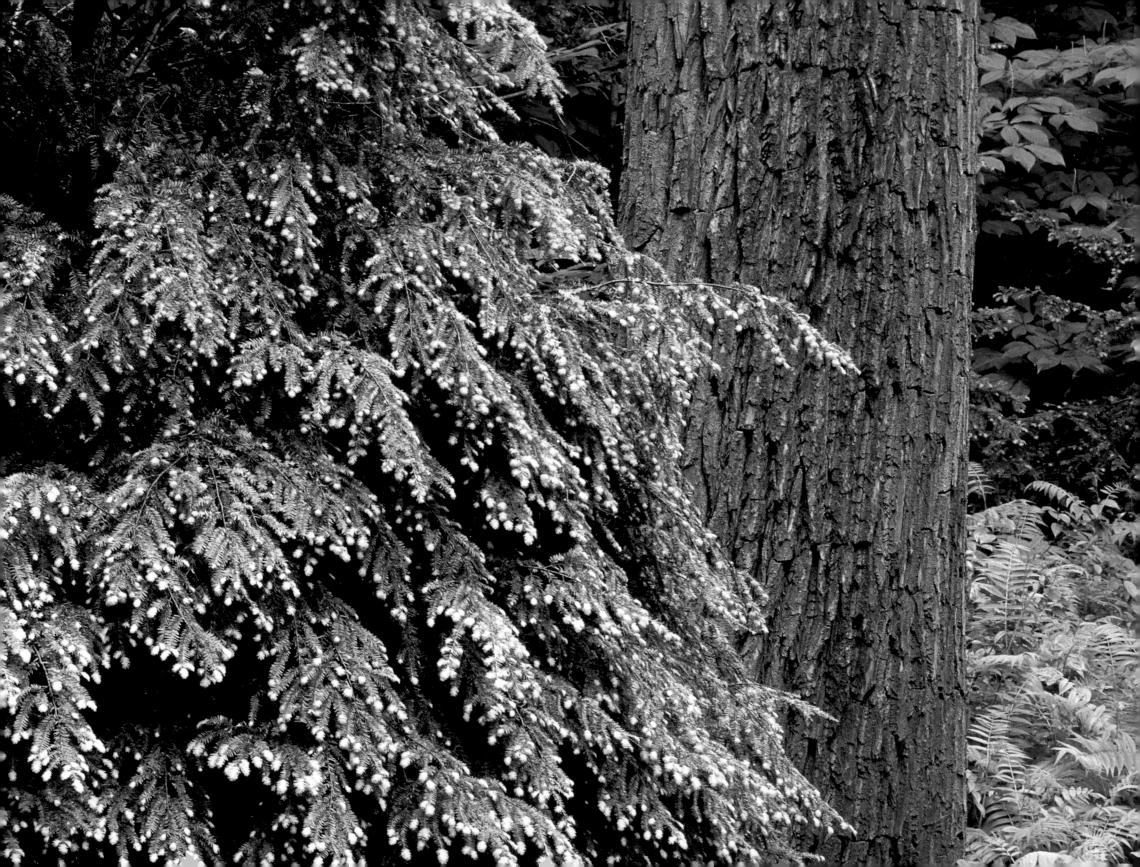

Once a neglected, brush-covered ravine, today the Woodland

Garden shelters an impressive collection of trees, shrubs, wildflowers

and groundcovers common to Ohio's three major forest types. Part

of the garden has been planted with exotic cousins of some native

plants, making for fascinating and educational comparisons. The

fruiting spike of the *Arisaema taiwanense*, for example, at right, is

more tightly packed, symmetrical and impressive than that of the

familiar American jack-in-the-pulpit *(Arisaema triphyllum)*, below.

Woodland Garden

Crowning glory: Cleveland Botanical Garden's
specimen trees would be the envy of many arboretums.
The collection of uncommon ornamentals includes a stunning sourwood
(Oxydendron arboreum), pictured on the left page in its early fall habit. Flowering crabs
a nd dogwoods, such as *Cornus florida* 'Variegata', this page, turn the campus into
a fairyland each spring. For sheer magnificence, however, nothing
surpasses a mature, native tree, such as the American beech
(Fagus grandifolia) featured on the following page.

Cleveland Botanical Garden's mission can be simply expressed: to make the wonders of plants accessible to everyone.

The Helen MacDonald Whitehouse Boardwalk
in the Woodland Garden in fall and winter

Photography
CREDITS